Creative Metal Sculpture

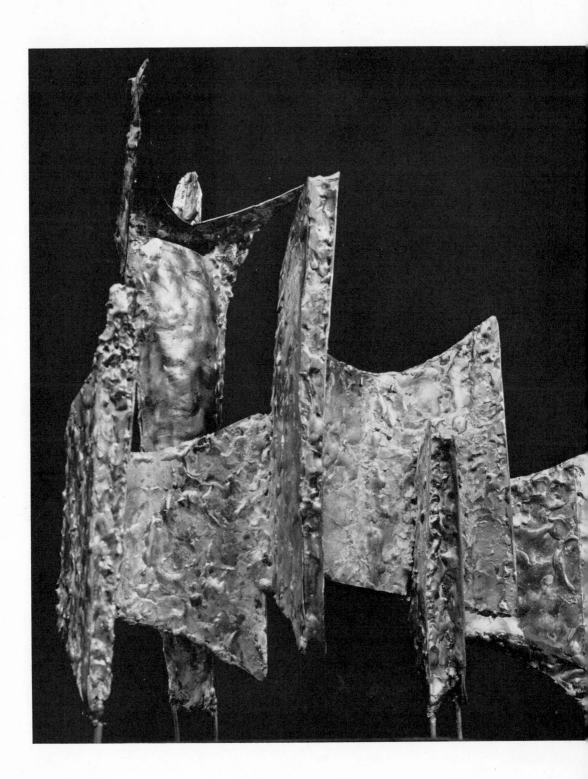

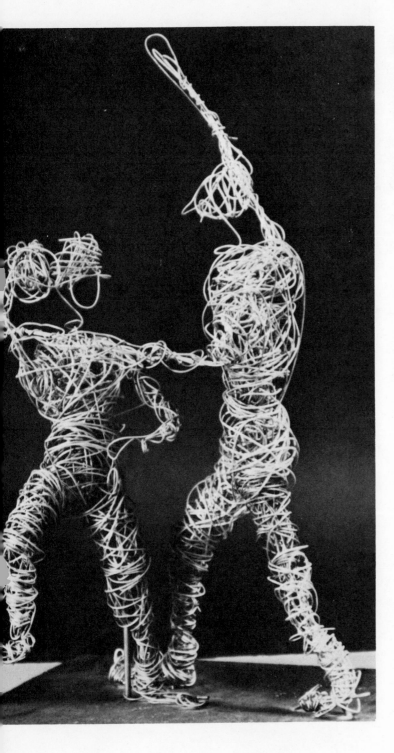

Creative

Metal

Sculpture

A Step-by-Step Approach

by

JOHN D. MORRIS

The Bruce Publishing
Company, New York
Collier-Macmillan Limited,
London

I lovingly dedicate this book to my wife Helen
whose sound judgment, organizational ability,
tireless good humor, and encouragement make it
all possible.

TITLE PAGE PHOTOGRAPHS:
Left: John Lefkow, *Man Against His Environment. Photograph by Carl J. Leonardi*
Right: Student work, South Side Senior High School, Rockville Centre, N.Y.

All drawings by the author. He also took the photo-
graphs of Simon Rodia's work, of the students',
and of the various processes.

Library of Congress Catalog Card Number: 75–158066

THE BRUCE PUBLISHING COMPANY
866 THIRD AVENUE, NEW YORK, NEW YORK 10022
COLLIER-MACMILLAN CANADA, LTD., TORONTO, ONTARIO

Made in the United States of America

Contents

Acknowledgments

IN expressing gratitude to the many people who helped to make this book possible, I first want to thank John Lefkow, who revitalized my interest in metal sculpture and who generously shared his expertise and studio facilities. Next, appreciation to editor Constance Bergman Schrader of the Bruce Publishing Company, who stimulated the writing of this book. In addition, I give my thanks to the students of South Side Senior High School, Rockville Centre, New York, and Stimson Junior High School, Huntington, New York; their creativity and interest in metal sculpture were a source of inspiration, and their talent is demonstrated in many of the wire sculpture photographs.

I also want to thank the many artists who generously provided photographs of their work, and the following individuals who eased the task of completing the projects and putting the book together: Anni Damaz; Arthur Kopf and Nicholas Fazio of Laurel Hardware, who helped with the selection and location of materials; Sam Trifaro, for his excellent darkroom work; Kathe Mulroy, for thoughtful and accurate typing; and Bonnie Lewis, for help with sculpture projects and art work.

Introduction to Creative Metal Sculpture

METAL sculpture is the most vigorous and fast growing of all of the modern arts. It offers the amateur artist or home hobbyist the twin satisfactions of making something with one's hands and creating a thing of beauty.

The eyes and the hands are the most important tools of creative metal sculpture. A great many attractive projects can be carried out with tools you probably already have in your home toolbox. The most elaborate projects involve only hot soldering, a simple process which is easy to learn. Then, too, the small scale of the projects means that a large workshop is not necessary. A kitchen table or corner of a workbench will provide adequate space.

The materials for the projects described in this book are available from neighborhood

1

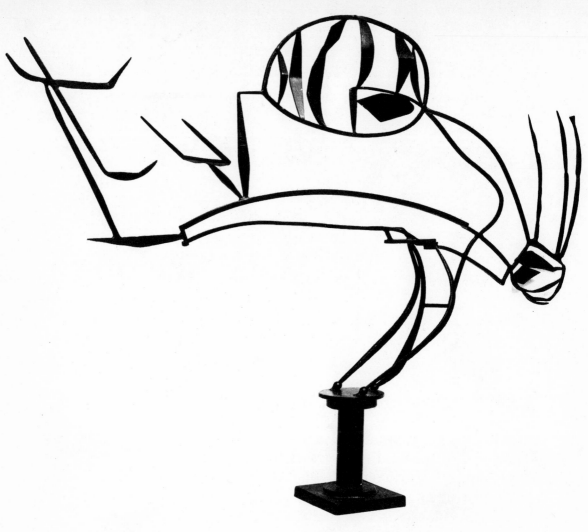

David Smith, *Australia*. Painted steel. Collection, The Museum of Modern Art, New York. Promised gift to the Museum of Modern Art, New York, from an anonymous donor. Photograph by Rudolph Burckhardt.

sources: hardware stores, lumberyards, and hobby or craft shops. These materials are not only readily available but inexpensive. Since the investment in materials is limited, the amateur sculptor need not hesitate to scrap a poor start and begin again.

The step-by-step procedures for completing each project will, however, keep mistakes at a minimum. Each project has been

2

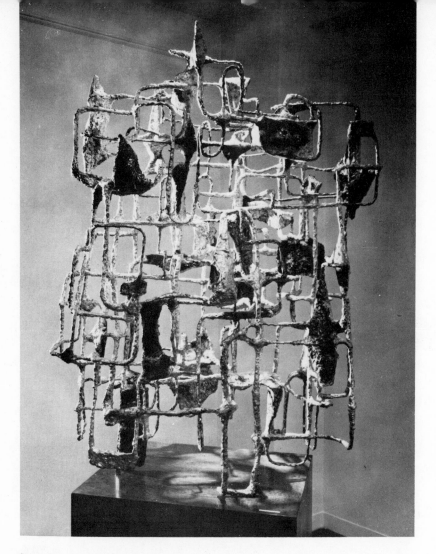

Ibram Lassaw, *October Continuity*.

carefully developed to ensure foolproof results. An extensive art background and technical training are not necessary. If you can follow directions and handle tools with reasonable ease, you will achieve successful results.

In addition to the projects that are outlined, numerous illustrations of professional work are included. These works by leading con-

3

temporary sculptors can spark your imagination and suggest other applications for the techniques you have learned.

ADDITIVE SCULPTURE

The type of metal sculpture that is dealt with here is called "additive sculpture." As its name implies, additive sculpture is a process of combining forms or adding shapes together to express a complete idea.

This form of sculpture is a twentieth-century development. For thousands of years, sculpture was defined as the art of carving or "sculpting" hard material to produce figures in relief or "in the round." The traditional sculptor imagined a form imbedded in stone and released it by carving away excess material. Today's additive sculptor creates his work from the inside out, building it up piece by piece. What happened, after thousands of years of carving, to bring about an entirely new form of sculpture? Additive sculpture developed because of the dramatic changes in the entire concept of art that took place during the twentieth century. Through a sequence of events in the artistic community, this new form of expression gradually evolved.

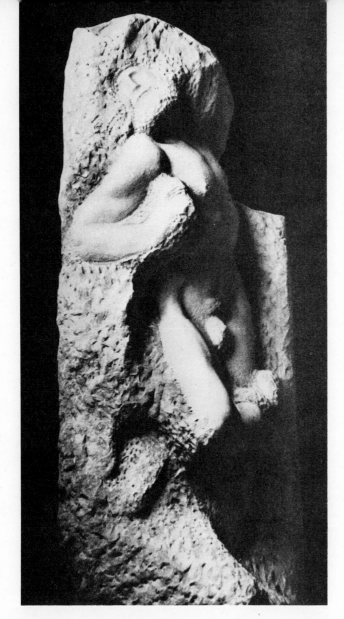

Michelangelo, *The Captive,*
unfinished.

First the cubists broke down the conven-
tional concepts of time and space, and freed
artists to see in new ways. Art scholars
theorize that additive sculpture was given

additional impetus by the invention of collage, which led to the exploration of new materials—string, paper, plastic, wire, and metal. However, Pablo Picasso recently claimed that he was the first to begin assembling sheet metal and wire into sculpture, with his *Guitar* in 1911 or 1912, and that this event antedated his first experiments with collage.

Pablo Picasso was one of the first artists to work in collage. In 1919 in Weimar, Germany, a group of artists led by Walter Gropius founded the Bauhaus School. Its purpose was to develop an art style that would be appropriate to the technical and mechanized culture of the twentieth century. Later, an American, Alexander Calder, added movement and lifted sculpture off its traditional pedestal for the first time in history.

The first half of the twentieth century was a period of great inventiveness for all artists. Sculptors were at the center of the search for new methods and materials, and were quick to adapt the advance of modern technology to their own uses.

Today's sculpture exhibitions provide evidence of great creativity and imaginative use of materials and techniques. They ex-

hibit pieces made of all kinds of metal, many forms of plastic, neon tubes, junk of all types, and an endless array of new materials. These materials are fired, welded, hammered, scratched, twisted, arranged, and disarranged, showing the tremendous variety of approaches available to the contemporary sculptor. The combining of materials—for example, wood and glass; wood, metal, and cloth—adds another dimension to the artist's sculptural effects. The juxtaposition of any selected materials is the artist's decision and choice. There is truly no limit to the forms additive sculpture can take. It offers challenge and pleasure to the beginner as well as to the professional. A small piece can be simply made for the coffee table; a decorative form can lend interest to an empty niche; a large piece can add drama to an outside wall or a garden.

Becoming familiar with the basic steps and introductory projects presented in this book can lead to more advanced procedures. The choice can range from the very fine wire sculpture of Richard Lippold (Figure 1) to the massive structures of Bernard Rosenthal (Figure 2).

Metal is such an adaptable medium that successful results can be attained with little

effort and a limited knowledge of art. Metal
sculpture embraces all levels of talent and
technical ability. There is no need to have
extensive training in art to begin construct-

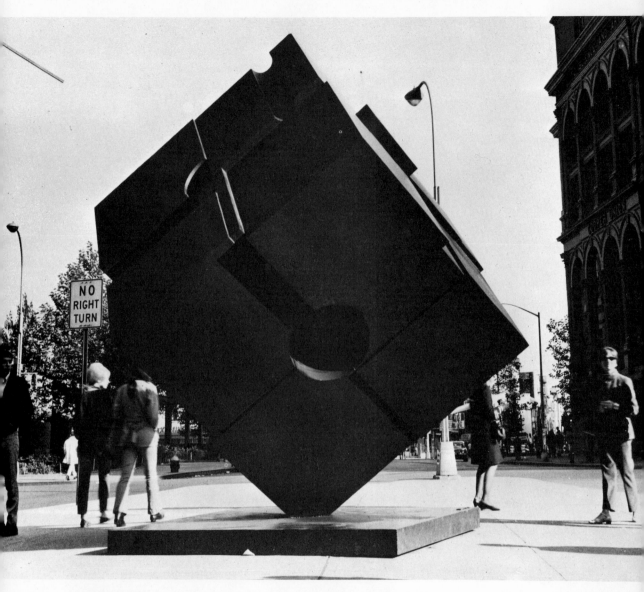

FIGURE 2
Bernard Rosenthal, *Alamo*. Collection of New York City.

ing sculpture in metal. Each artist relies on
his own aesthetic judgment. Each endeavor
has a unique quality that is an extension of
the person who created it, that justifies its

9

Charles Reina, *Totem.*
Cut oil drum.

existence. There is no right or wrong, good
or bad; the act of creating is rewarding in
itself. And creativity is an innate quality
common to all. It needs only to be exer-
cised, revitalized, nourished. Let metal
sculpture be the vehicle through which
your own aesthetic judgment and intuitive
selectivity find their outlet.

10

2

Making
Two-Dimensional
Wire Sculpture
by Bending and Twisting

THE simplest way to start metal sculpture is to work with wire. Exciting results are achieved by bending and twisting wire and then securing it in a base or hanging it so that the sculpture seems to float in space. Because wire sculpture allows the beginner to enjoy satisfying results in a short period of time, it is recommended as one of the first types of metal sculpture to try.

Simplicity is the essence of this type of sculpture. It is similar to a line drawing, a pencil sketch, or even a cartoon—and for this reason the best results are achieved through a quick and spontaneous approach.

11

Alexander Calder, *Sow*. Wire construction, 17 inches long. Collection, The Museum of Modern Art, New York. Gift of the artist.

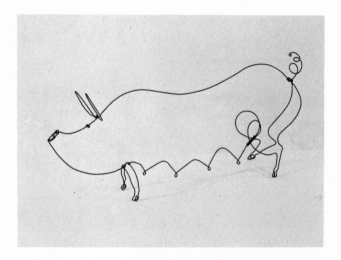

Because of the highly linear nature of two-dimensional wire sculpture, begin with a mental picture of the linear form that you want to represent. In selecting a subject choose one that lends itself to representation in linear form. A natural form, such as an animal or bird, is appropriate for this type of sculpture. For your first project, think of a form that can be represented in a single line. The easiest way to start might be with the silhouette or outline of a fish, bird, or animal. Try to visualize your subject at its simplest. Try not to become distracted with the details; let the person who sees your work fill in the details according to his own associations.

The only tools needed are three inexpensive and common types of pliers (Figure 1): **needle-nosed pliers; snub-nosed pliers;** and **side-cutters.** Choose the size and type that feels most comfortable to you. A large selection of these pliers can be found at most hardware stores.

TOOLS

1. Ordinary **steel wire,** available in any hardware store, is used for wire sculpture.

MATERIALS

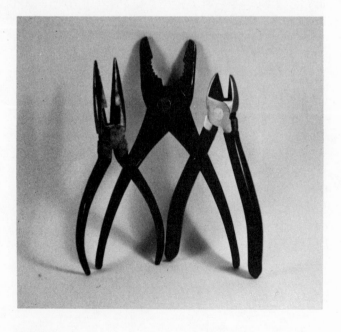

FIGURE 1
From left to right: needle-nosed pliers, snub-nosed pliers, and side cutters.

The most adaptable kinds of wire are 30-, 20-, 16-, and 12-gauge (Figure 2). These sizes will provide the variety of effects needed for most beginning projects.

The more advanced sculptor may wish to use **brass, copper,** and **aluminum wire.** These, however, have the disadvantage of being available only through special sources.

Another good source of wire is the scrap bin of an electrical repair shop. **Plastic**

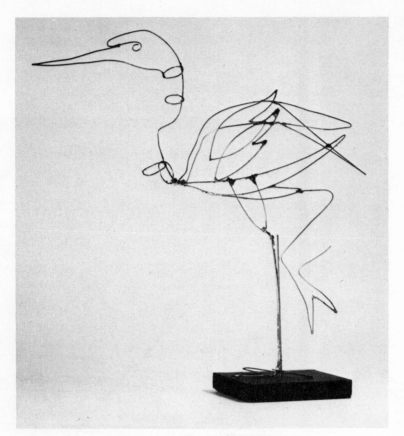

coated wire in a variety of colors can provide exciting and beautiful effects.

2. A readily available base for wire sculpture is a **block of wood** of appropriate dimensions. With a little sandpapering, the wood base is ready to be stained or sprayed with paint. It can then be finished with varnish if a shiny surface is desired.

If you would like to use something simpler, yet just as effective, try a square-edged **cake of soap** as a base for your early sculptures.

15

Collection of Helen and
John D. Morris.

Scrape off the manufacturer's name with a paring knife, then rub the cake smooth under running water. The soap base can be left white or sprayed with acrylic paint for a colorful touch.

16

3. The linear qualities of wire sculpture are not easily appreciated when silhouetted against a patterned background. Instead, place your sculpture against a light-colored wall, or use a **piece of cardboard** that contrasts with the wire as a backing. Proper lighting will also enhance the effect. Try placing lights at a dramatic angle above or below the sculpture.

As previously mentioned, an animal, fish, or bird shape is recommended for a first project. Before you begin, visualize an animal you know well, or perhaps use a photograph or drawing for reference. Look for action; try to capture in your piece the flight of a bird; the running, twisting, turning of an animal; or the squirming of a fish. All of these gestures and attitudes add to the dynamic quality of the sculpture (Figures 3 through 6).

Begin by using the side cutters to cut a 5' length of 20-gauge wire. Wrap masking tape around the ends to prevent scratching your hands or arms. Then twist and turn the wire into the desired shape. As you work with the wire, be sensitive to its "feel" and tend-

PROCESS

FIGURE 3

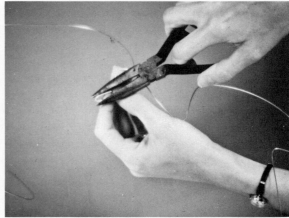

FIGURE 4

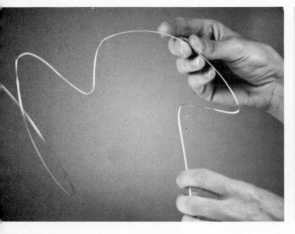

FIGURE 5

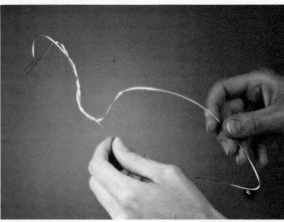

FIGURE 6

ency to bend in a special way. Guide the wire as you would a pencil if you were making a line drawing.

Use your needle-nosed pliers to make sharp bends and to help in making tight twists.

18

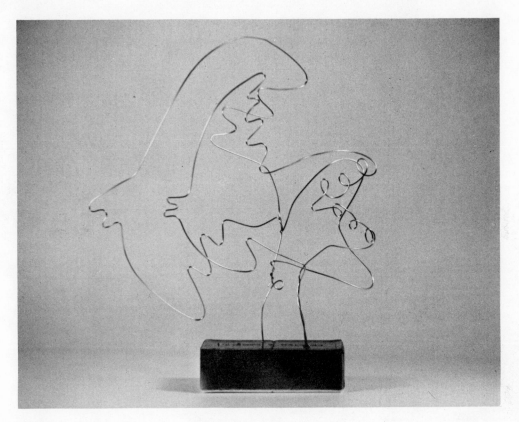

FIGURE 7
John D. Morris, *Fish*.

If you want to hold two sections of wire together while twisting, use a piece of masking tape.

Don't try for a truly representational form; rather aim to capture the gesture that will

19

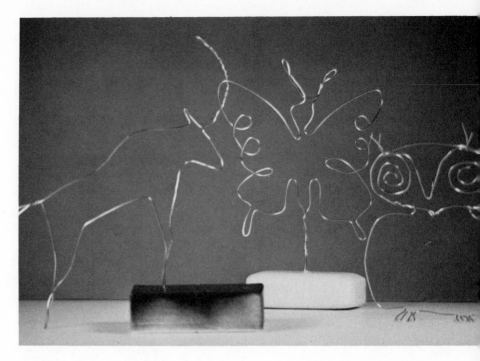

South Side Senior High School,
Rockville Centre, N.Y.

South Side Senior High School
Rockville Centre, N.Y.

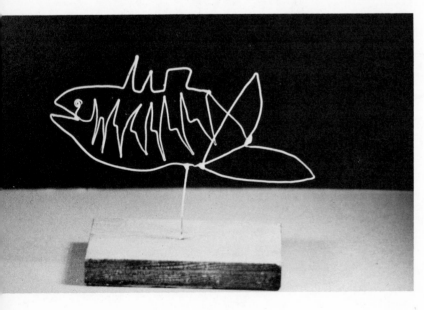

20

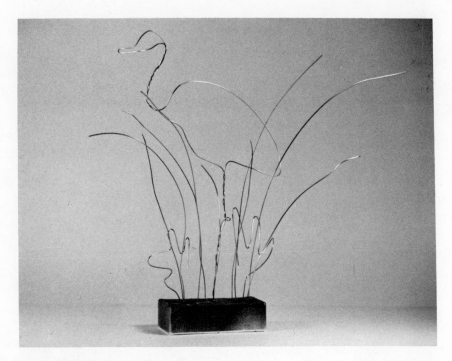

John D. Morris, *Heron*.

better convey an attitude. Keep your first efforts simple.

When you have finished shaping the wire, cut off any extra with the side cutters. Mount the sculpture on a soap base by inserting the wire into the soap.

After you have tried several single forms, experiment with two or more forms. Repeat the same form in smaller and larger sizes, as shown in Figure 7, the fish sculptures. Combining different forms on one or more bases will also provide some interesting effects.

21

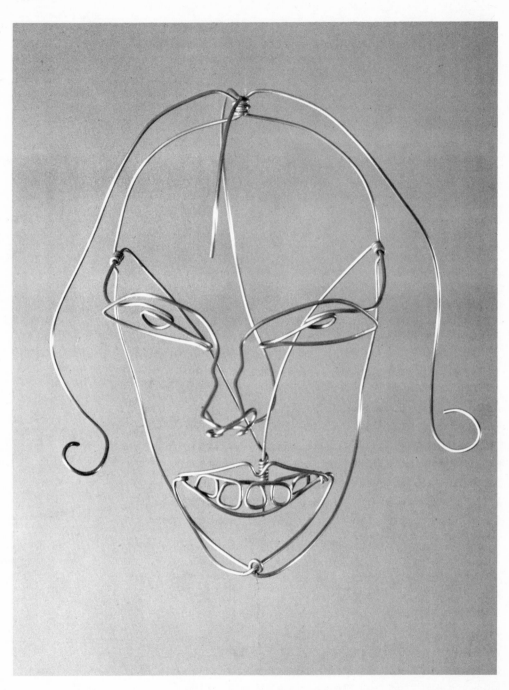

Alexander Calder, *Marion Greenwood*. Brass wire. Collection, The Museum of Modern Art, New York. Gift of the artist.

3 Three-Dimensional Wire Sculpture

AFTER creating two-dimensional sculpture, you are now ready to move to another stage—the addition of the third dimension. Instead of representing a form with just height and width, you now add the element of depth. Instead of the form being seen from one vantage point, as a flat surface, it can now be seen from all sides. In creating this three-dimensional sculpture, you will use the bending and twisting processes that were used in Chapter 2.

Working in three dimensions is, of course, a little more complicated; but the added dimension will greatly increase your ability to express ideas. It will invite you to attempt other works of art that you might once have thought impossible. The forms and styles of sculpture that you admire will have more meaning for you and will help you to develop your own style.

23

Alexander Calder, *Soda Fountain*. Iron wire, 10¾ inches high. Collection, The Museum of Modern Art, New York. Gift of the artist.

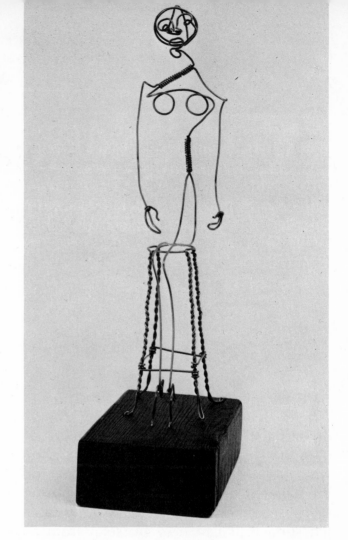

Alexander Calder, *Cow*. Wire construction, 16 inches long. Collection, The Museum of Modern Art, New York. Gift of Edward M. M. Warburg. Photograph by Eric Pollitzer.

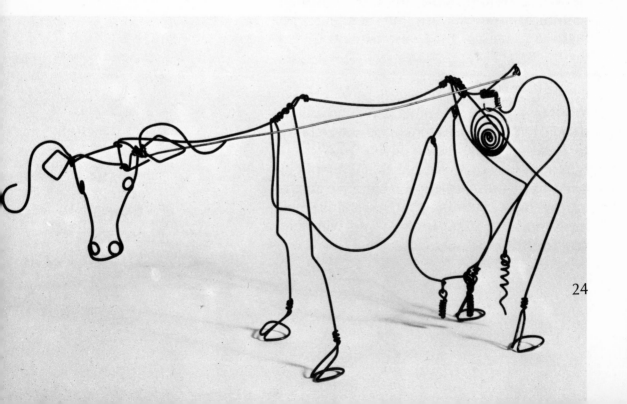

24

In this chapter, two new techniques are introduced: (1) the use of cold solder to fasten wires together, and (2) the addition of color to both the wire and the base.

You will need no additional tools. The three kinds of pliers that were used in the last project will be suitable.

1. Wire, 16-, 20-, and 30-gauge.

2. LePage's **liquid solder** should be used as an adhesive to hold the pieces together. This can be purchased at any hardware store. There are other adhesives on the market with which you may wish to experiment at a later time, but LePage's solder should be used for this project.

3. Two cans of **acrylic spray paint,** brass-toned for the wire and flat black for the base. Acrylic spray is recommended for its covering and quick-drying properties.

4. A roll of **masking tape.**

5. A piece of **balsa wood** 3" \times 5" for the base. Balsa wood is available in 3" \times 3'

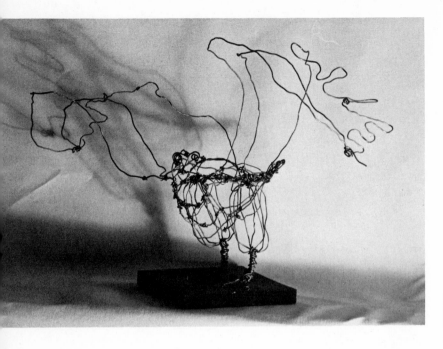

Katie Van Delft, *Hawk.*
South Side High School,
Rockville Centre, N.Y.

Wire pig.
South Side High School,
Rockville Centre, N.Y.

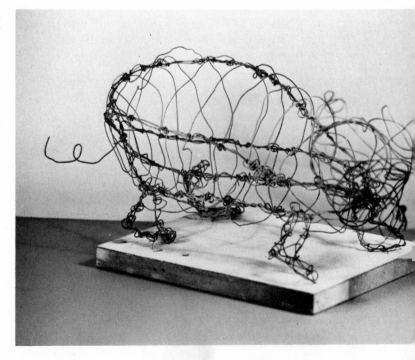

26

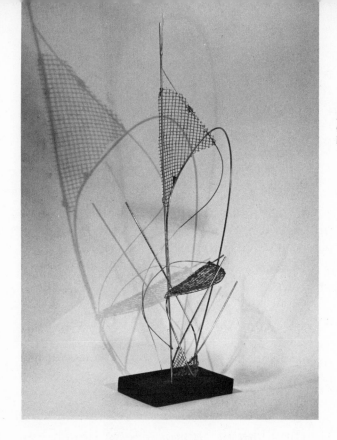

Left: Margaret Sleiertin, *Configuration.* Stimson Junior High School, Huntington, N.Y.

Below: Elephant. South Side Senior High School, Rockville Centre, N.Y.

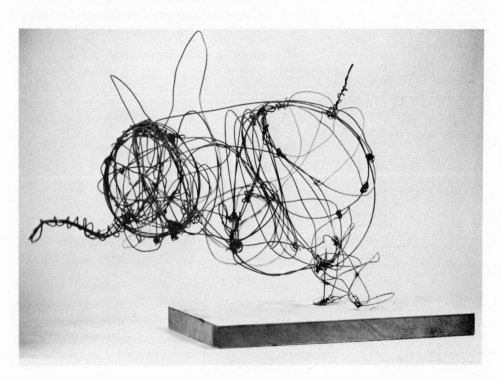

sections at any hobby or craft shop; such a piece will serve for many projects. Balsa wood is recommended because of the ease with which you can insert the ends of wires into this soft wood.

After you have cut a piece of balsa wood for the base, spray it with the flat-black acrylic paint.

PROCESS The problem of adding a third dimension will not seem so difficult if you see it simply as adding depth to a flat form. Here is a simple example: converting a square into a cube.

Take one square:

Add a second square behind it:

Add connecting lines (the third dimension).

The third dimension can be added to a more complex form in the same way:

Take the outline of an automobile.

Add another outline behind it.

28

Add the connecting lines, and you have made a drawing of a three-dimensional shape.

The first project suggested for three-dimensional wire sculpture is based on an animal form that lends itself to this treatment—a squirrel.

Delbe Thode, *Loop the Loop.* Stimson Junior High School, Huntington, N.Y.

Figure 1 shows how a charcoal sketch of a squirrel was translated into a simplified outline. Notice how the silhouette of the squirrel is represented by the lines of the outline.

Figure 2 shows the linear outline of the squirrel's form; this will serve as the basis of the sculpture.

Figure 3 shows the final sculpture of the squirrel incorporating three dimensions.

Figure 4 shows all the elements that were used in the sculpture. Notice that each element was created either in duplicate—for example, the tails at the left (Elements 7 and 8)—or by doubling and pulling apart to add the illusion of depth (Elements 1–6). Refer to Figure 4 when following the directions for making a three-dimensional wire sculpture.

After cutting and bending each piece, spray with brass-toned acrylic paint and allow to dry before mounting. When spraying, place the piece of wire on newspaper. Make sure that you cover the surrounding area, as it is almost impossible to restrict the spray of paint to a small area.

Elements 1 through 5 are made of 16-gauge wire.

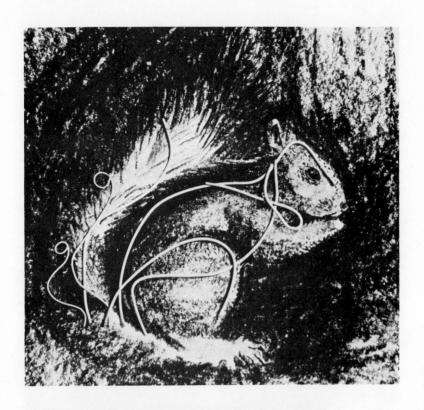

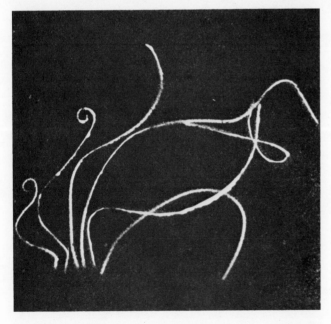

FIGURE 1
Above: Charcoal rendering
by John D. Morris.

FIGURE 2

FIGURE 3
Right: John D. Morris,
Squirrel.

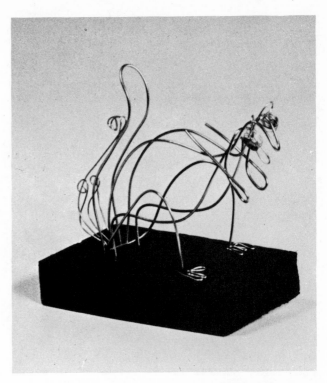

FIGURE 4

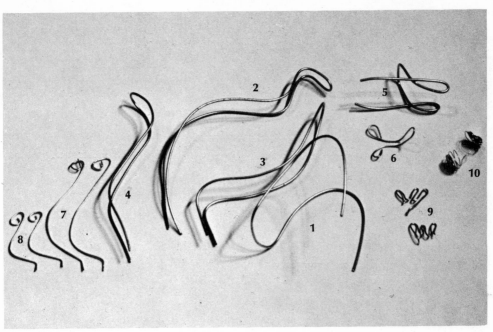

To create Element 1, cut a 12" piece of wire and bend it, as indicated in Figures 5 and 6. Insert it into the base, as shown in Figure 7.

To create Element 2, cut a 16" piece of wire. Bend and insert it in base, as shown in Figure 8.

Element 3 is made from a 13" piece of wire. Bend and insert it into base, as shown in Figure 9.

FIGURE 5

Create Element 4 from an 11" piece of wire. Bend and insert it in base, as shown in Figure 10.

Element 5, the forepaws, is a 9 1/2" piece of wire. Bend it as shown in Figure 4. Drop it over the head and let it rest in place, as shown in Figure 11. Apply solder to join the ends of the arms to the back of the squirrel, as shown in Figure 12.

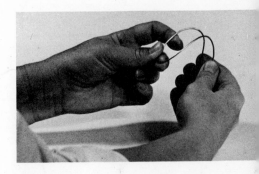

FIGURE 6

Elements 6–9 are made of 20-gauge wire.

Element 6, the ears and lower jaw, is bent from a 5" piece of wire. Tape this in place with masking tape, as shown in Figure 13. Then apply solder to fasten this piece to the head. Leave the tape in place until the solder dries.

FIGURE 7

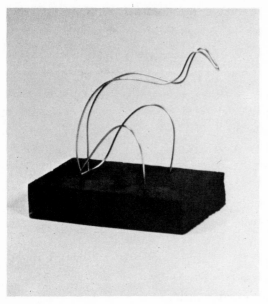

FIGURE 8

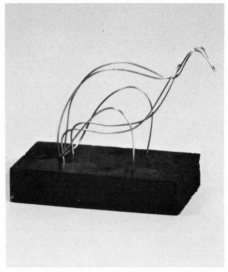

FIGURE 9

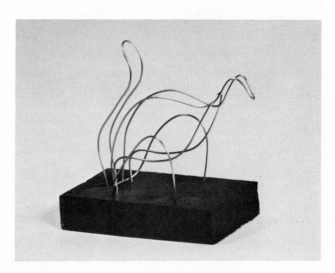

FIGURE 10

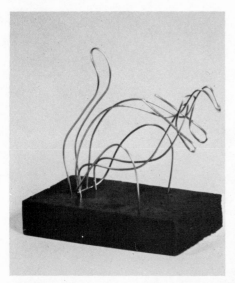

FIGURE 11

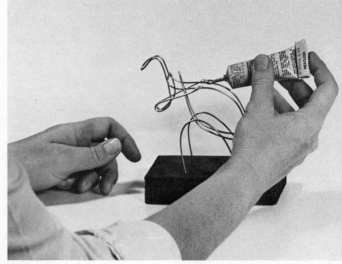

FIGURE 12

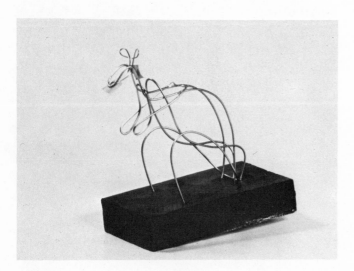

FIGURE 13

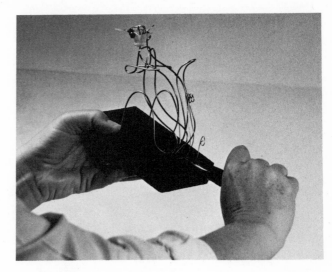

FIGURE 14

Element 7 is bent from two 5″ pieces of wire; Element 8 is bent from two 3″ pieces. Notice that the bottom of each of these tail pieces is turned to make them easier to insert in the base. Anchor these pieces as shown in Figure 14.

Element 9, the feet, are created by making a series of bends with the needle-nosed pliers, as shown in Figure 15. Turn down one end of each piece to make it easier to push into the base.

Element 10, the eyes, are made of 30-gauge wire. Create two small spirals by wrapping

36

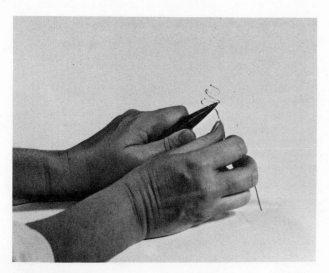

FIGURE 15

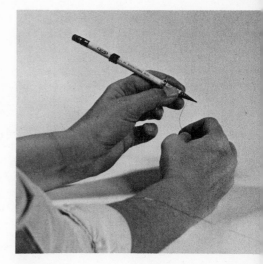

FIGURE 16

wire tightly around the point of a pencil, as shown in Figure 16. Flatten each spiral, and add a drop of solder in the center for solidity. Also use solder to fasten the eyes to the head.

Examine the finished piece after completion. When I made the sample, I noticed that the haunches looked somewhat incomplete, so I added two more pieces at the bottom. It is good practice to take a fresh look at a piece several days after it is finished in order to make a final aesthetic judgment. Sometimes valuable additions

37

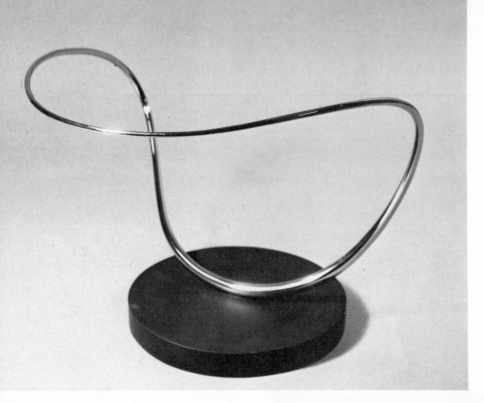

Above: Jose de Rivera,
Construction 8. Forged rod,
stainless steel, 9⅜ inches high.
Collection, The Museum of
Modern Art, New York. Gift of
Mrs. Heinz Schultz in memory
of her husband.

Right: Bertoia, *Untitled (Moon).*
Stainless steel, 40 inches
diameter. Staempfli Gallery,
New York. Photograph by
John D. Schiff.

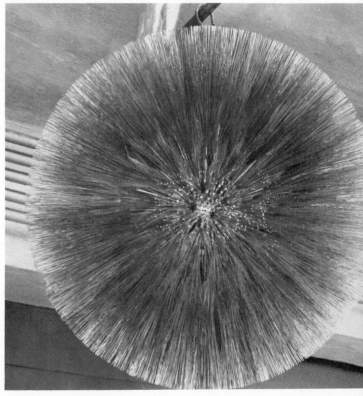

and corrections can be made at this point. There is, however, the danger that later tampering can alter the character of a piece to such an extent that it becomes a new piece. Knowing when to stop is as important as knowing how to begin.

Convergence. Silas Seandel Studio, Inc., New York.

Reg Butler (Reginald Cotterell Butler), *The Unknown Political Prisoner (Project for a Monument)*. Welded bronze and brass wire and sheet on limestone base. Collection, The Museum of Modern Art, New York. Sadie A. May Fund.

40

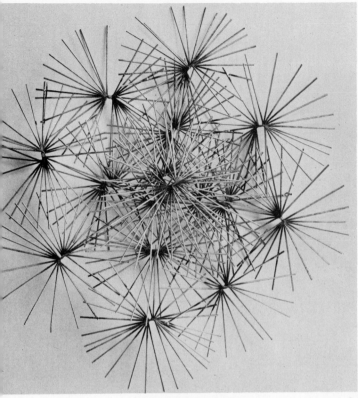

William Bowie, *Sunburst*. Gold-leafed copper-coated steel rods, 54 inches diameter. The Sculpture Studio, Inc., New York.

Rooster. Collection of Marcia and William Dehn.

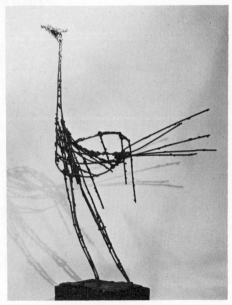

41

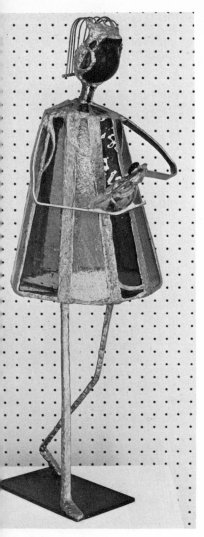

Eva Cossock, *Mini-Mom.*

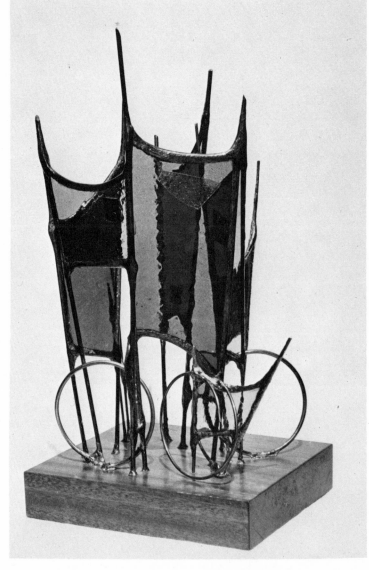

Eva Cossock, *Regatta.*
Photography by Jim Haun.

42

Wrapped-Wire Sculpture Based on an Armature

IN the last chapter, the objective was to work in three dimensions: height, width, and depth. Because the sculpture was in linear form, you could see through it. You worked with the outside of the form, and volume was suggested by the interior space. In this project, you will fill the interior space and add the element of solidity by working from the inside out, starting with a central core and building the form around it (Figure 1).

First you will construct an armature to serve as the core or skeleton of the form (Figure 2). The armature must then be shaped to determine the action or attitude of the

43

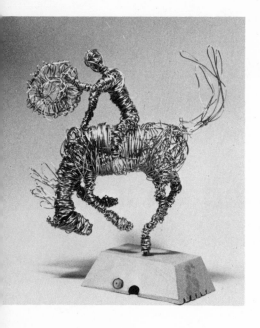

Deborah Gurley, Stimson Junior
High School, Huntington, N. Y.

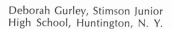

Deborah Gurley, Stimson Junior
High School, Huntington, N.Y.

object. Wire is then wrapped around the armature to add thickness or volume.

The wrapping process requires no special technique or advance planning and is best done in a spontaneous "play it by ear" manner. Hold the armature in your hands and start anywhere, wrapping round and round, moving up and down the form until you have built up enough wire to create the desired thickness. Feeling the form grow in your hands and seeing it develop through the kinesthetic process of wrapping adds a great deal of fun and excitement. This technique will not only develop your visual aesthetic judgment, but it will also add a new factor—tactile judgment, the ability to evaluate something on the basis of how it feels. The inherent urge to touch and feel is common to all. Have you ever had the desire to touch paint and see if the Wet Paint sign means what it says? The tactile sensation is as important as seeing, for texture—the roughness or smoothness of an object—adds still another dimension to sculpture.

The wrapping technique lends itself especially well to the representation of human or animal figures in action. In planning the subject for your wrapping project, visualize

44

WRAPPED-WIRE SCULPTURE BASED ON AN ARMATURE

FIGURE 1

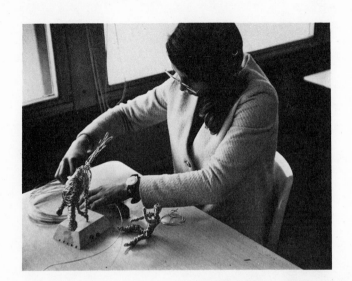

FIGURE 2

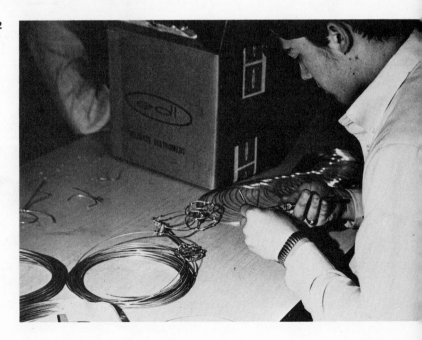

it in its simplest form, for this kind of sculpture does not allow for any consideration of details. Instead, it forces you to concentrate on form and movement, on capturing the vitality of life. Action should be the keynote and the main emphasis of your sculpture.

Pat Mohr, Stimson Junior High School, Huntington, N.Y.

Kenny Green.

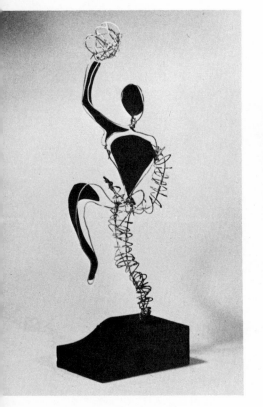

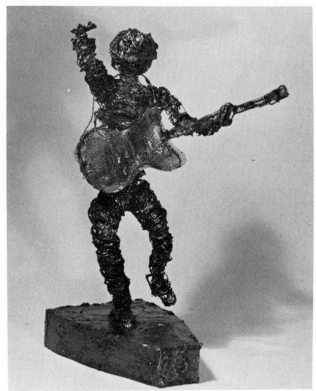

WRAPPED-WIRE SCULPTURE BASED ON AN ARMATURE

Victor E. Zaikine. From the collection of Ilse and Anthony Curto.

Lori Mohrmann.

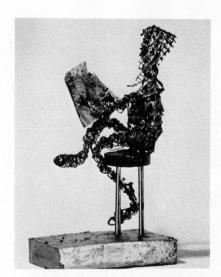

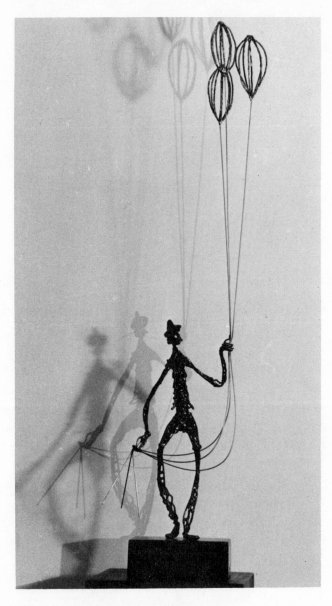

Nancy Viccora.

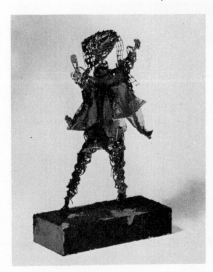

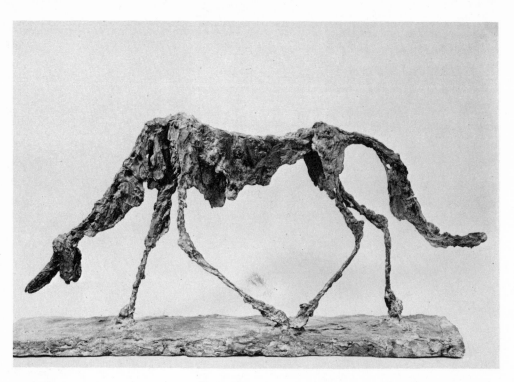

Alberto Giacometti, *Dog.* Bronze, 18 inches high.
Collection, The Museum of Modern Art, New York.
A. Conger Goodyear Fund

As you start the next project, try to recall the feelings you experienced and the insights you gained while doing previous projects. You now know that a straight or curved line made longer or shorter might express a more dynamic form. Adjust yourself to the concept that distortion will make a stronger statement and convey a more meaningful expression than will strict adherence to absolutes. An overextended arm or leg, a twist of the body or tilt of the head might be just the right touch to give your piece that indefinable distinction.

TOOLS

You need no tools other than the **pliers** and **cutters** used previously.

MATERIALS

1. For the armature, you will need a small quantity of **16-gauge wire.** (Wire specially made for use in armatures can be purchased at most art supply stores, but the 16-gauge type is recommended for this project.)

2. For wrapping, you will need a large quantity of **20-gauge wire.** To help you determine the approximate amount you will need, bear in mind that the skier shown in Figures 3–6 required about 500 feet or 1/2 lb. of a six-inch roll.

3. Because of the weight of wrapped-wire sculpture, a solid wood base is recommended. A simple rectangular **block of wood** can be quite satisfactory; however, if a jig saw is available, the base can be shaped to carry out the action of the sculpture and can thus serve as an important design element. The skier is a good example of this. The wood base can be painted, stained, or left in its natural state. Other materials that provide interesting bases are stone, plastic, plaster, or metal.

4. Glue will be needed to attach the sculpture to the base or one piece of wood to

49

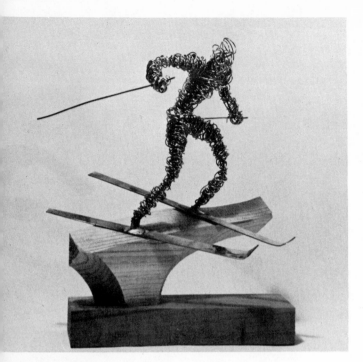

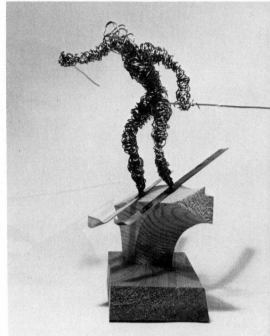

FIGURE 3
Nancy Shook, Stimson Junior
High School, Huntington, N.Y.

FIGURE 4

another. Elmers Glue-All is recommended. (Glue is not always essential for this purpose; the motorcycle in Figure 7 was attached to three nails driven into the wood by applying liquid solder where the wire wheel touched the nails.)

PROCESS First make the armature, using 16-gauge wire. Try to keep your piece under nine

50

FIGURE 5

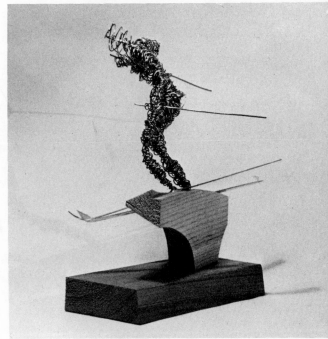

FIGURE 6

inches in height. For added strength, use a double wire for the core of the form. A single wire will suffice for arms and legs. The cross members can be fastened to the core with thinner wire. Since the armature will not show when the piece is finished, the appearance of the fastenings is not as important as their strength.

After you have constructed the skeletal core, bend it to set its action. The turn of the

body, the thrust of an arm, will give your sculpture the feeling of movement and life.

Now you are ready to start wrapping the armature with 20-gauge wire. Wrap the wire freely and at random. Do not wrap too tightly at first. Keep moving over the armature until you achieve a relatively correct anatomical form. Wrap more wire as necessary to reinforce and accentuate the vitality of the form. Loose ends can be tucked into the wound wire and secured.

As you work, keep turning the sculpture in your hands so that you can see it from all sides. As you turn it, you will see and feel where it needs more wire. And remember, if you change it on one side, it may need to be changed on the opposite side. Don't be satisfied until all angles are studied—that is, from eye level and from below as well as above. When you are satisfied with your form from all angles, you are ready to mount it on a base.

Variation #1
After you have completed several projects made with an armature and wrapped wire, you may want to try a variation of this technique. A looser but more controlled type of wrapping makes it possible to produce forms such as the horse in Figure 8.

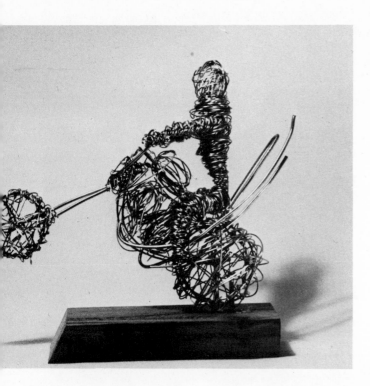

FIGURE 7
Kenneth Lawson, Stimson Junior
High School, Huntington, N.Y.

FIGURE 8
Katie Van Delft. South Side
High School, Rockville Centre, N.Y.

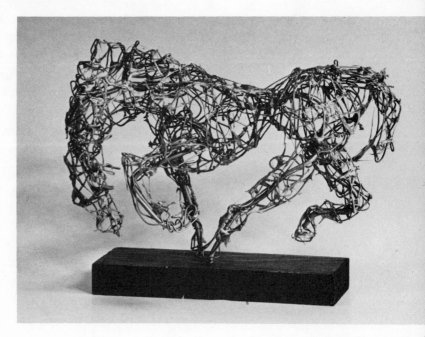

53

FIGURE 9

First an armature was formed from 12-gauge wire (Figure 9). Then thin wire (20-gauge) was bent into curves and loosely wrapped into the form of the horse. Notice that the wrapped wire surrounds the volume of the horse's shape. Unlike the previous project, which was wrapped from the inside out, the wrapped wire forms the outer contour of the horse's form, and the inside is hollow.

After the basic shape was completed, lighter wire (30-gauge) was added to create more definition and texture. Next, liquid solder was squirted lightly over the entire form in order to support the wire structure and to add interesting texture. Finally, the entire piece was sprayed with silver acrylic spray paint and mounted on a wooden base.

The frog in Figure 10 represents still another variation of the armature with wrapped wire. In this example the wire was wrapped very loosely around the armature to suggest the form of the frog. Then the form was encrusted with auto-body putty. Notice that the entire form was not covered; just enough putty was added to keep the wires from slipping out of position, and to suggest the bumpy texture of a frog's skin. The open spaces that remain add interest and intrigue to the sculpture.

Variation #2

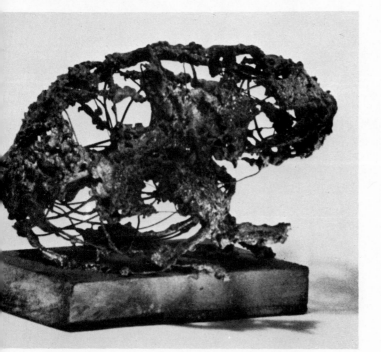

FIGURE 10
Lynn Haberstock. South Side
High School, Rockville Centre, N.Y.

The surface thus becomes an important part of the sculpture and of the original planning. Its roughness or smoothness gives the piece a tactile quality and sometimes a particular surface quality helps to define the total effect.

John D. Morris, *Bull.*

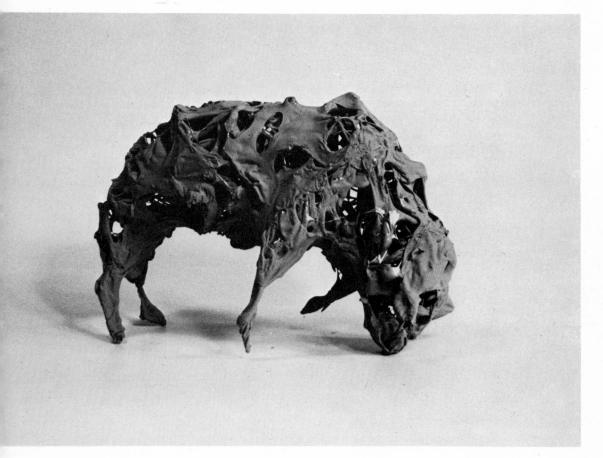

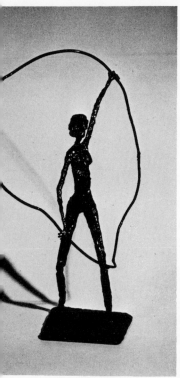

Eugene Davidson.
Courtesy Steffen Galleries, New York.

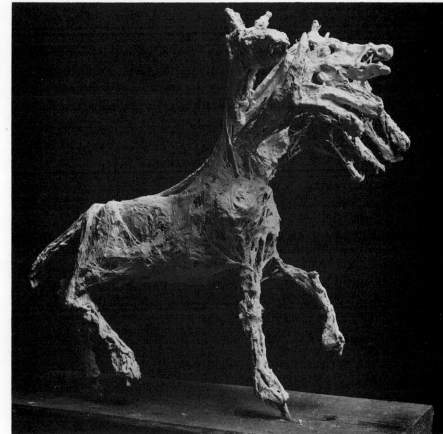

Germaine Richier, *Six-Headed Horse*. Plaster over string and wire. Collection, The Museum of Modern Art, New York. Gift of Mrs. Katharine Kuh. Photograph by Rudolph Burckhardt.

57

Francisco Perez,
Juggler.

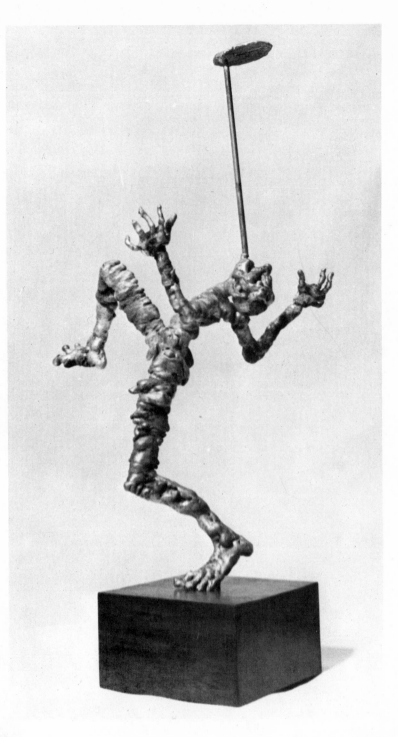

5

Finishes and Patinas

THE finish that is applied to metal sculpture is almost as important to the piece as is its initial construction. An imaginatively selected and artistically applied finish can add great impact and beauty.

Because anything that adheres permanently to a surface can be used to finish metal sculpture, there is an almost endless variety of finishes and patinas available. Most of them are easy to obtain and to use, for they require no special equipment. Some are common household products.

The decision as to what type of finish to use will be dictated by your purpose. If you don't like the color of a finished piece, you may want to cover it completely with some kind of paint. Bronzing powder or liver of sulphur can be used if you want a metallic sheen or an antique look. Highlights and accents can be achieved with a variety of substances.

59

Bernard Rosenthal,
Roundelay. Bronze.

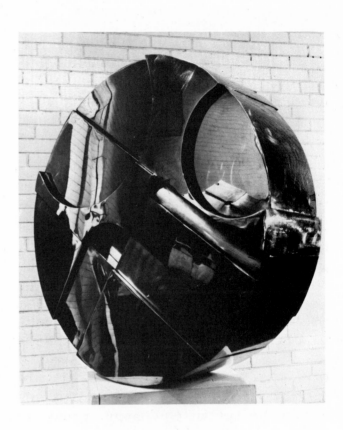

SPRAY PAINTS Acrylic spray paint is one of the most effective and easily used finishes. It is readily available from a variety of stores and comes in a full range of colors, including metallic tones such as copper, brass, and gold.

Spray paint has the advantages of covering completely, penetrating easily into cracks and crevices, and drying quickly. It offers

60

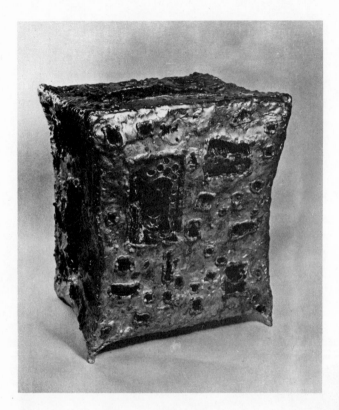

Ibram Lassaw, *Labyrinth II.*
Bronze.

Anthony Wagar, *Dukes.*
Stainless steel and enamel.

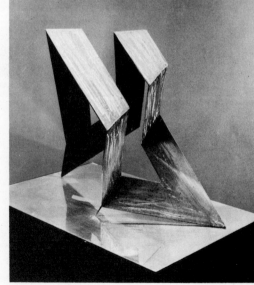

the possibility of interesting and varied fin-
ishes with a minimal amount of preparation.
Keep in mind that the spray valve cannot be
adjusted, so it is impossible to exert careful
control over the area to be covered. It is
therefore wise to spray out of doors or in a
workroom. If you must work in a confined
space, protect the area around the object
being sprayed with a shield made of large

61

pieces of cardboard topped with a newspaper (Figure 1).

When you spray, hold the can about twelve inches away from the object. Keep moving the spray can so that you avoid a build-up of paint in any particular spot. The spray dries completely in a matter of minutes.

Interesting effects can be achieved with spray paint. If you want complete coverage and a density of color, it is better to spray the piece several times rather than to use

FIGURE 1
Cardboard and newspaper shield for spray painting.

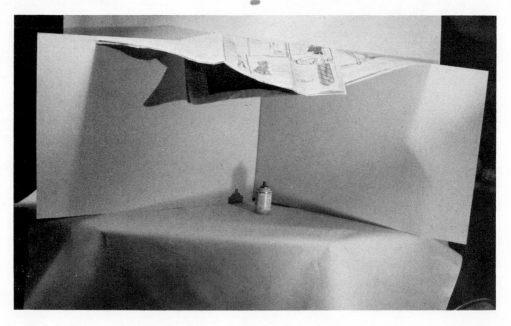

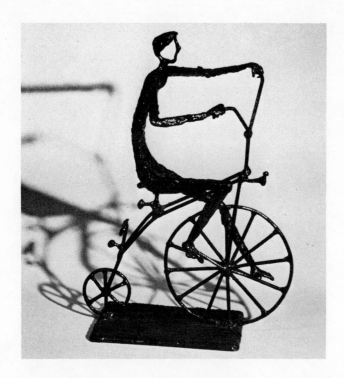

FIGURE 2
Eugene Davidson. Courtesy Steffen
Galleries, New York.

one heavy coat. The paint might peel or
flake off if it is applied too heavily. Although
a single color can be striking, on occasion
you might wish to add a second light coat
in a different color or in a metallic tone. An-
other interesting effect can be achieved by
spraying the piece first with varnish or shel-
lac. While the first coat is still wet, spray
lightly with a color. The added color will
appear to be suspended on the wet varnish
or shellac and will create the effect of a
transparent film which allows the metal to
show through (Figure 2).

After completing the spraying process,
spend a minute clearing the valve so that it

will not become clogged with dry paint. Clearing is accomplished by turning the can upside down and depressing the valve. (Here, again, take the usual precautions.) In about three seconds, no more paint will come out. Then you know that the valve is clear and the spray can is ready to be stored. If the valve should become clogged, it can be reopened by inserting a very thin wire into the valve hole. If this doesn't work, the valve can be removed and soaked in lacquer thinner.

AUTO BODY PRIMER AND CASEIN PAINT

Auto primer and casein paint can be used to produce another interesting and unusual color finish. First spray the piece with two coats of grey metal auto primer. When it is dry, brush on a heavy coat of white casein paint. Then add the color you have chosen in a highly diluted solution. Before this dries, use a dry cloth to rub off enough colored paint to achieve the desired patina. If the paint should dry too quickly, dampen the cloth to remove it.

BRONZING POWDERS

Bronzing powders, while slightly more complicated to use than paint, offer greater depth and richness of color. They also make

it possible to achieve a very handsome antique effect. In addition, the powders can be used to give a metallic finish to materials other than metal, such as wood, plastic, and plaster.

Bronzing powders, which are available from art supply and paint stores, come in many

John Lefkow, welded brass buffet.
Photograph by Carl J. Leonardi.

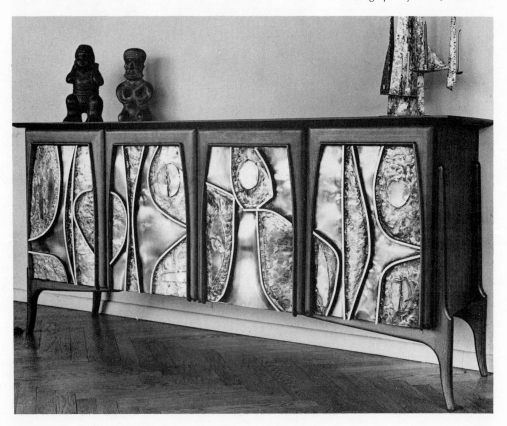

Charles Reina. Brass rods and
enameled sections.

colors. There is a wide range of metallic
tones, from the lightest golds to the deepest
blackish-brown bronzes, as well as a rich
blue and green.

Before it is used, the powder is mixed with
bronzing lacquer to the consistency of milk,
and applied with a brush. One ounce of
powder and a small amount of lacquer will
provide more than enough to cover one
piece of sculpture.

66

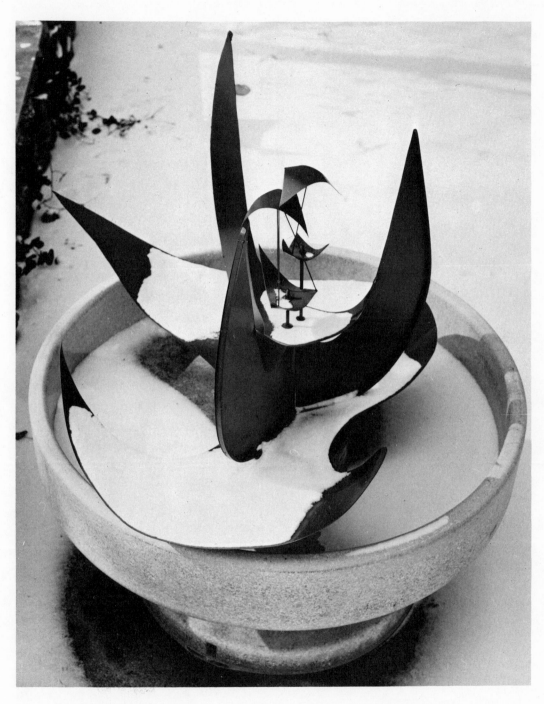

John Lefkow, welded brass fountain.

To achieve an antique effect, use two colors. For your first attempt, you might try antique copper, a dark tone; and natural copper fine, a light shade. Use the dark color as a base, making sure it goes into all the crevices. Then add the light value for highlights. Buffing the finishes after they are dry will give additional highlights. When you have had some experience, try adding a touch of blue or green for a special effect.

LIVER OF SULPHUR

When mixed with water, liver of sulphur powder turns the surface of certain metals yellow, brown, or black, lending a very realistic antique look. It affects copper, brass, bronze, and other nonferrous metals, but has no effect on sheet metals.

Liver of sulphur can be purchased from art supply or craft shops in liquid or in solid form. If you buy the liquid—a half pint will be adequate for most of the projects you will be doing—remember that it is full strength and will need to be diluted. It is best to experiment a bit to determine just how much to dilute it. At full strength, it will turn metal almost black and might peel off. The more it is diluted, the more yellow it becomes.

68

In solid form, liver of sulphur is sold by weight. A half pound will be sufficient. Start by mixing a half-teaspoon in a cup (eight ounces) of water. After testing the effect, you will be able to decide whether to add more powder or more water. When mixing, do not be alarmed by the smell of rotten eggs; that is the natural odor of sulphur.

Before applying the solution, it is advisable to clean the metal, for even the oil residue from your hands will affect the resulting patina. Use soap, water, and steel wool. A steel wool soap pad, such as Brillo, is excellent for this purpose. Allow the piece to dry thoroughly before proceeding.

Use a soft brush to apply the liver of sulphur solution. If the metal becomes darker than you want, use a steel wool soap pad to clean off the surface. Then start again.

When you have finished, wash your brush in water. Although liver of sulphur is not harmful to the skin, it is good practice to wash your hands after using it.

An unusual patina can be achieved by using heat after you have applied liver of sulphur. While the metal is still wet, apply heat with a propane torch, and beautiful red colors will appear.

69

FIGURE 3
Collection of Helen and
John D. Morris.

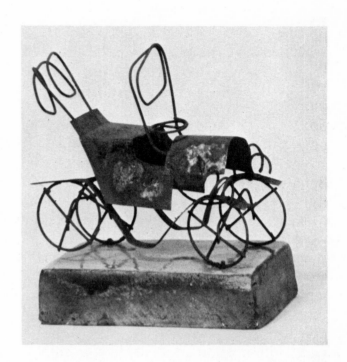

MURIATIC ACID Because it eats away the protective coating of zinc and other rust-proofing additives, muriatic acid can be used to produce a rusted, weathered, or highly textured surface on sheet metal.

Exercise caution when using muriatic acid and do not allow it to touch your skin. Rubber gloves are recommended, and a brush should be used for application. If the acid should get on the skin, wash immediately with water. This acid will also harm wood

70

furniture and floors, upholstery, and clothing, so be careful where you use it. Be sure to have water handy for use in stopping the acid's etching action.

If you want a pitted or textured surface, pour the acid on the piece and allow it to remain until you have achieved the desired effect. This may take several hours. Stop the action by pouring cold water over the piece.

If you want a rusted surface (Figure 3), first remove the protective coating from the sheet metal with muriatic acid and then wash the piece to stop the action of the acid. Keep the piece wet or leave it in a damp place until the desired amount of rust has accumulated. If you want to stop the rusting action, dry the piece and spray it with clear plastic spray. Omit the plastic spray if you want the rusting to continue.

6 Hot Soldering

THE fastening problems in the projects up to this point have been solved rather simply by twisting wires or by using cold solder. There are limitations in these ways of fastening, however, and as you get into more complex projects, you will need a method that permits stronger and more permanent joints. Hot soldering answers this need, and is introduced now for use in forthcoming projects.

There is nothing mysterious about soldering; it is a relatively simple process that can be mastered with a little practice. Basically it involves heating the two pieces to be joined so that they will accept the hot solder which forms a bond.

TOOLS

1. The best type of heating agent is a **propane torch,** available at any hardware store. Such a torch is relatively inexpensive and

73

has many uses other than making metal sculpture. The torch consists of a nozzle and a bottle of propane gas (Figure 1). It will not be necessary to buy a second nozzle, but additional bottles of propane gas can be purchased to replace the initial one after it has been used up. The propane torch is easier to use than a soldering iron because you can regulate the amount of heat, and the flame heats faster and covers a larger area. Should you already have a soldering iron, however, try it out before purchasing additional equipment.

2. Clamps are needed to hold together the pieces to be soldered. Wooden household clothespins work well for this purpose, although there are many kinds of clamps available that you may find more useful. Bear in mind that there will be times—when you are building vertically, for example—when no type of mechanical clamp can hold the members in proper position for soldering. Then the only thing you can do is to get the help of another person.

MATERIALS **1. Acid-core solder,** the bonding agent, is sold in rolls at all hardware stores (Figure 1).

2. Soldering paste (Figure 1), sometimes called flux, will be needed for removing the

74

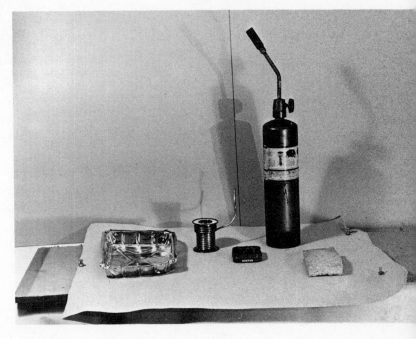

oxides from the metal so that the solder will "take." It is also useful for correcting mistakes. If you overheat the metal, you will create strong oxidation and the metal will not absorb the solder. When this happens, clean the metal, touch it up with soldering paste, and start again.

3. Heat-resistant material is needed for the working surface. An effective fireproof surface can be created with two layers of insulating building board covered by two thicknesses of asbestos paper. The building board, being of very dense material, will char under a flame but is very unlikely to burn; the asbestos paper is fireproof. Both materials are available at a lumberyard or builders' supply house. This combination

has an added advantage: you can impale pieces in the building board to hold them in place while you are soldering.

4. A **sponge** in a dish of water should be available for use in cooling the soldered pieces. Also have some **rags** handy. You will use wet rags to prevent heat from traveling through the metal when you solder joints that are close together.

PROCESS Place the two parts to be soldered in the desired position and clamp them together. This will free you to use both hands in the soldering process.

Apply soldering paste at the point where the members are to be joined.

Holding the solder in one hand and the propane torch in the other, use the torch to heat the metal parts. This makes the metal receptive to the solder. Some people make the mistake of dripping the hot solder onto the joint and are disappointed when it doesn't hold. Remember, the metal has to be hot to accept the solder. Also bear in mind that thicker metals require more heat than thin metals.

76

Keeping the metal hot, bring the solder down to the joint and allow it to flow onto the joint. The amount required depends on the thickness of the metal; you will learn to judge this with experience. As soon as enough solder has flowed on, remove the heat and immediately cool the joint, using the water-filled sponge.

If you overheat the parts to be fused, the solder will not adhere because oxidation has taken place. When this happens, clean the parts with steel wool and soap or a Brillo pad. Touch them up with soldering paste and start again.

When you have completed one joint and want to solder another along the same piece of metal, wrap a wet rag around the piece between the completed joint and the place where you are now going to solder. This will keep the heat from traveling through the metal and melting the joint that is already soldered.

After soldering, clean all joints with a detergent to remove any remaining soldering paste. Acid in the soldering paste might cause rust to form on the iron in some materials. And, of course, covering the finished product with varnish or plastic spray will retard any further rusting action.

77

Jim Hagan, *Brass Bed.*

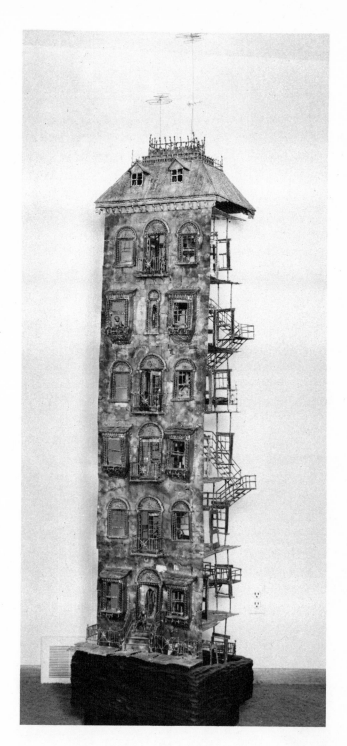

7

Sculpture with Wire, Foil, and Sheet Metal

USED alone, wire can produce a great variety of effects, as you have seen in Chapters 2, 3, and 4. Adding copper foil or sheet metal to wire opens up a whole new range of design possibilities. Flat pieces of metal can be cut into an infinite variety of shapes. Planes, either flat or curved, can be created. Bent or folded pieces of metal can be used to suggest volume. Many subjects will occur to you as you let your imagination explore the possibilities of wire and flat metal pieces in combination.

Two quite different projects are suggested for you to try. The first one is a flower arrangement, constructed of copper foil and music wire. The second is a "tin lizzie" type of car, made with sheet metal and wire.

79

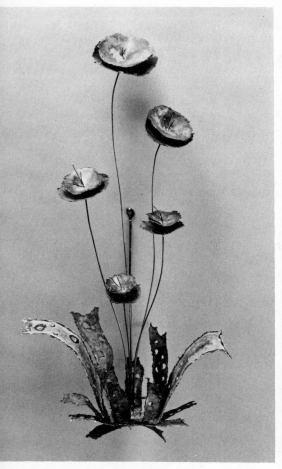

Silas Seandel, hanging wall flower.
Steel, copper, and brass.
Silas Seandel Studio, Inc., New York.
Photograph by Gil Amiaga.

Standing floral. Silas Seandel Studios, Inc., New York.
Photograph by Gil Amiaga.

Project 1: Flower Arrangement

This project introduces a new feature, the kinetic element. The sculpture is constructed so that the flowers will sway back and forth as the air around them moves, or if they are set into motion.

This kinetic quality is achieved by careful selection of materials. Most important is the

80

music wire. This wire has both stiffness and a springlike quality. If you hold a piece upright in your hand, it will stand up straight and sway back and forth. Unless it is bent with great force, it will return to its original shape.

Music wire was chosen for this project because of this quality of flexible stiffness. It is used for the stems of flowers and leaves because it has the strength to support their weight, and the flexibility to sway and move attractively despite their weight.

The steel wire used in previous projects is not suitable for this project because it lacks rigidity and resiliency. If you attached a flower to a length of steel wire, the weight of the flower would bend the wire down and it would not spring back.

By the same token, music wire cannot be used for the kinds of projects for which the steel wire was used. Music wire can be bent only with pliers and by exerting great force. Its springiness prevents it from being wrapped.

Thus you can see that each type of material has its own characteristics that make it suitable for certain kinds of projects but unsuitable for others. In planning any project,

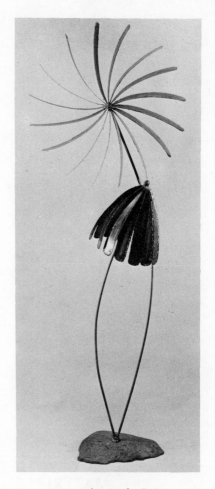

John Steck, *Daisy*.
America House, New York.

81

therefore, be aware of the inherent qualities of the materials you have to choose from; choose materials whose qualities conform to the requirements of your design.

TOOLS

1. **Soldering equipment,** as described in Chapter 6.

2. Assorted **pliers,** as used in previous projects.

3. **Tin snips.**

4. **Scissors.**

MATERIALS

1. The blossoms and leaves of the flowers are made of **copper foil,** which can be purchased by the pound or by the yard at hobby or craft shops. **Copper flashing,** available from lumberyards, may also be used for this project. The flashing is slightly heavier than the foil, which is usually 32-gauge. A yard of either foil or flashing (probably the minimum purchase) will prove more than adequate for this project.

2. **Music wire** is used for the stems of both flowers and leaves. It is available from

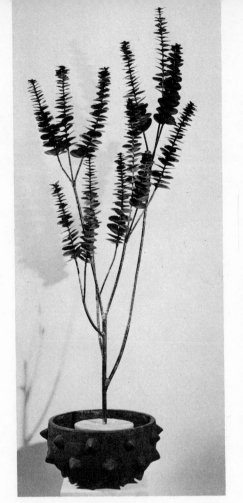

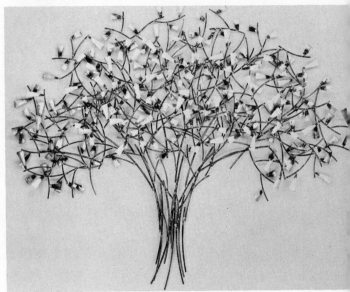

John Steck, *Eucalyptus*. Burnished and oxidized copper. America House, New York.

William Bowie, *Wedge Tree*. Gold-leafed steel, silver accents. The Sculpture Studio, Inc., New York.

hobby or craft shops in yard lengths and in various gauges. Recommended gauges for this project are 1/16, 1/32, and .045 of an inch. The number of lengths you purchase will depend on the number of flowers and leaves you put into your piece. Eight lengths of various gauges were used in making the arrangement in Figure 1: five lengths for the five flower stems and three lengths for the five leaf stems.

3. A block of **balsa wood** is used for the base.

FIGURE 1
Kenneth Lawson.

PROCESS First cut out the blossom shape. Copper foil is light enough to be cut with household scissors, but you will need tin snips to cut the copper flashing. To make each blossom, start with a 4″ square. Shape the edge, and then cut into the center to form petals. Bend the petals to form a blossomlike shape. After you have had some experience with this medium, you may wish to cut a number of layers of petals for each flower. You would then place the petals inside each other and create many-layered blossoms.

When you have completed the blossoms, apply heat with the propane torch and create a patina of varying shades of red. While the metal is still hot, pour cold water over it to bring out rich reds and browns.

84

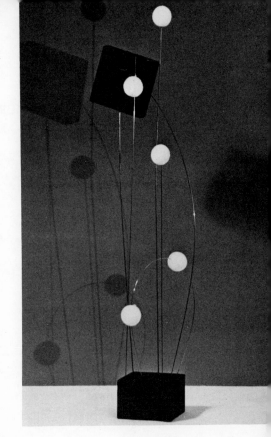

Pat Mohr, Stimson Junior High School, Huntington, N. Y.

Next cut the leaves, taking care that they are properly proportioned. You may wish to use heat to give the leaves a red patina, or you may prefer to use liver of sulphur or bronzing powder to add color, as described in Chapter 5.

To create stems for the flowers, use side cutters to cut the music wire into pieces of appropriate length. With your pliers, bend the end of each wire about a quarter of an inch into a right angle. This creates the part that will be soldered to the blossom.

Holding the bent end of the stem against the bottom of the blossom, apply a dab of soldering paste to the parts to be joined; then apply solder. The instant the solder starts to flow, remove the heat and the solder. Apply cold water to set the bond. Fasten a stem to each blossom in this manner.

Now hold all the flowers, blossoms up, and notice how they sway. The amount of sway depends on the length of the stem and the weight of the blossom. To achieve the desired amount of movement, alter the length of the stem or the weight of the blossom until you are satisfied.

Next cut the stems for the leaves and solder

85

them to the leaves. Here, too, you are interested in a graceful, swaying action.

Arrange the blossoms and leaves as you would flowers in a vase and insert them into the balsa wood base. If you have the right balance, the entire arrangement will sway gracefully as the air around it is set into motion.

Many variations on this theme are possible. Styrofoam balls can be used instead of, or as part of, the blossoms. They can, of course, be sprayed in a variety of colors.

Project 2: The Car

This project offers an excellent opportunity to consider the factors of design and material in relation to each other. First let us consider the design. Looking at the car (Figure 2), you will notice that it has great simplicity. The artist chose to include only the basic elements of an automobile: four wheels, body, windshield, steering wheel, fenders, and headlights. Thus he abstracted the essence of what makes a car a car. He was not concerned with realism but rather wished to create a decorative impression of a car.

Next notice the choice of materials. Sheet metal is a natural choice for the body. First,

86

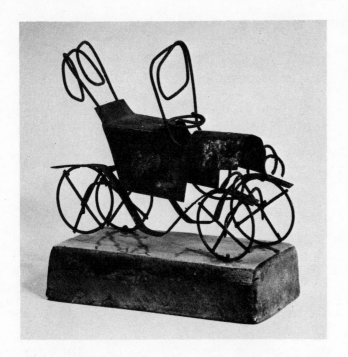

FIGURE 2
Collection of Helen and
John D. Morris.

it is heavy enough to lend rigidity to the structure. Second, it lends itself to a rusty finish, which is particularly appropriate for a "tin lizzie." The wire used for this project is 12-gauge. Heavy wire is important to the design, for it lends substance and solidity. If the wire were too thin, it would be out of balance with the solid-looking body; it would also look flimsy, and the character of the piece would be lost.

TOOLS

1. **Soldering equipment,** as described in Chapter 6.
2. Assorted **pliers,** as used in previous projects.
3. **Tin snips.**
4. **Clamps** and/or **30-gauge wire.**

87

MATERIALS
1. **Sheet metal** is used for the car body.
2. The car's frame is made of **12-gauge wire.** You will need about a yard for this project.
3. **Heavy paper** or **cardboard** for a pattern.
4. To achieve a rusty look you will need **muriatic acid** (see Chapter 5).
5. A **block of wood** is needed for the base.

PROCESS
Before constructing the car, it might be well for you to start by making a pattern, in order to develop your ideas with more planning than has been done with previous projects. This will allow you to make errors in judgment that can easily be corrected by making additional patterns.

Start by making a pattern of the car's body, using any kind of heavy paper or cardboard. Visualize the car's body in two-dimensional form, and draw this form on your paper. Cut out the pattern with scissors and bend it to the desired shape. If your first pattern doesn't turn out well, make another. Keep making patterns until you have the desired shape.

Next place your pattern over the sheet metal, mark it off, and then cut out the shape. Bend the shape into a three-dimensional form. This provides the major form

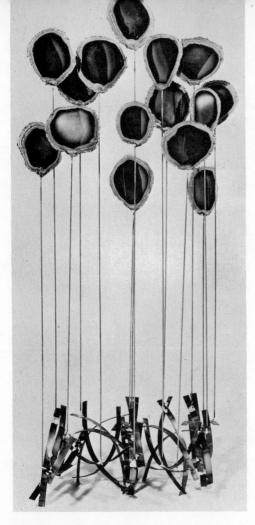

William Bowie, *Peacock Chimes*. Copper and steel, bronze accents. The Sculpture Studio, Inc., New York.

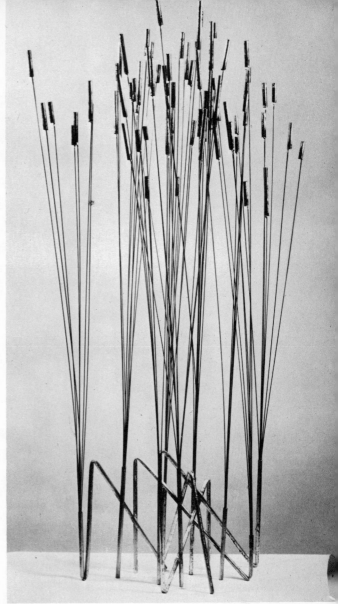

William Bowie, *Cattails*. Gold-leafed steel. The Sculpture Studio, Inc., New York.

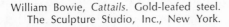

of the sculpture and serves as the base to which the wire frame is attached.

Shape the wire into the various component parts and attach them with hot solder to the body of the car. It is best to work from the bottom up, and to work out a soldering procedure that allows several pieces to be soldered at the same time. This can be done

89

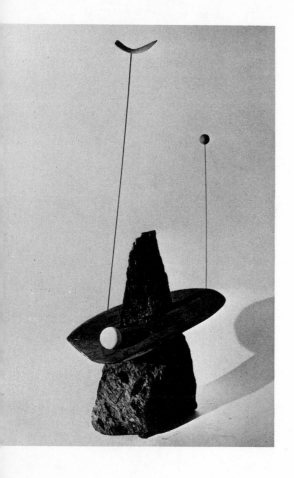

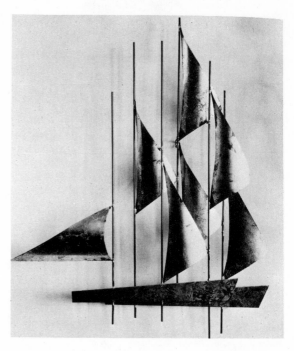

Alexander Calder, *Gibraltar*. Collection, The Museum of Modern Art, New York. Gift of the artist.

William Bowie, *Clipper*. Gold-leafed steel. The Sculpture Studio, Inc., New York.

by using clamps. Or, if clamps prove too awkward, wrap the pieces to be soldered with 30-gauge wire to hold them together until the solder is applied. When all the soldering is complete, cut away the 30-gauge wire.

When the wire pieces have been added to the body, make the fenders. It may be helpful to make a paper pattern before cutting the fenders. Then solder the fenders to the wheels and body.

90

Jim Hagan, *Birds*.

John D. Morris. Welded brass.

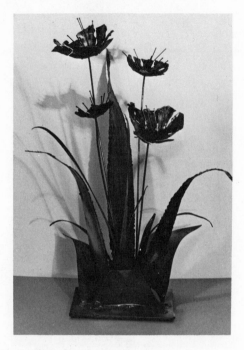

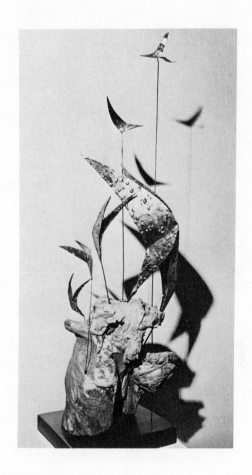

When the structure is complete, apply the finish or patina. To achieve the rusted finish shown in the photograph, remove the protective coating with muriatic acid, as described in Chapter 5, and then keep the piece damp until the desired finish is achieved.

The piece illustrated in Figure 2 was fastened to a ceramic base that has a glazed surface. But a wood or stone base can be just as effective.

91

Alexander Calder, *Morning Star.*
Collection, The Museum
of Modern Art, New York.
Gift of the artist.

8 Textured Foil and Sheet Metal

UP to this point you have had a great deal of fun making things out of wire, and materials in conjunction with wire. Now let's try a project using just sheet metal or copper foil, singly or in combination.

One new element in this chapter is the addition of texture to the surface of the metal. Texture is added in two basic ways: by beating the metal with a round-headed hammer, and by dripping hot solder on the metal. These techniques have another beneficial effect: they increase the strength and rigidity of the metal. Using these two techniques, you will able to achieve textural effects that are similar to those seen in the examples. Even though some of these pieces are made of brass and bronze that was welded and brazed with an oxyacetylene torch, they are included here to suggest effects that you can achieve, but on a smaller scale. The reduced scale is necessary because of the limited strength of the mate-

Semaphore. Welded and brazed brass, bronze and copper. Silas Seandel Studio, Inc., New York. *Photograph by Gil Amiaga.*

93

Jim Hagan, *American Gothic.*

Kiwi Bird, Silas Seandel Studio, Inc., New York. *Photograph by Gil Amiaga.*

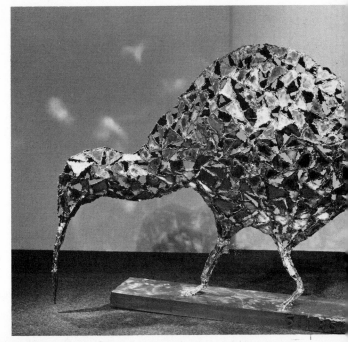

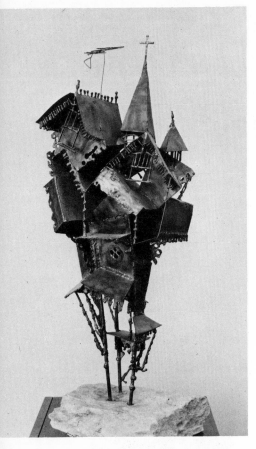

John D. Morris, *Offbeat.* Welded brass.

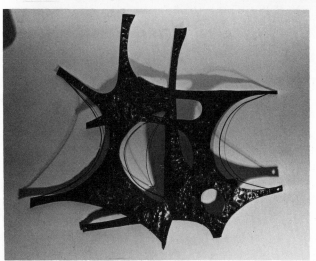

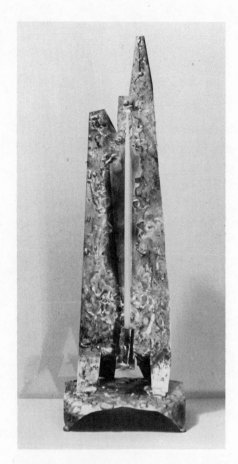

FIGURE 1
John D. Morris. Sheet metal
and hot solder.

rials available from your local lumber or
hardware supplier, and the limited strength
of the bonds that can be achieved by hot
soldering.

Each of the five projects in this chapter in-
volves slight differences in procedures, but
all make use of textured sheet metal and
copper foil.

The candelabrum suggested for your first
project (Figure 1) will provide you with

Project 1: Candelabrum

practice in a number of techniques for creating textured sheet metal. It will also be the first time you will be making something that has functional as well as artistic value. There is a fine line between something that is purely artistic and that which is designed with a utilitarian aspect. Frank Lloyd Wright designed houses that were considered sculptural. Some of today's classic furniture was designed not only to support people, but also to stand on its own as a piece of sculpture. Care must be taken with the design, for if function dominates, it will weaken the artistic value of the piece. It can become gimmicky and lose all of its important artistic qualities.

TOOLS

1. **Soldering equipment,** as described in Chapter 6.
2. **Round-headed** or **machinist's hammer.**
3. **Needle-nosed pliers.**
4. **Tin snips.**

MATERIALS

1. **Sheet metal.**
2. Piece of **heavy cloth** to absorb the blows of the hammer.
3. **Caulking cord,** to be placed in the sleeve which holds the candle.
4. One or more **tapers,** or slender candles.

Make the base of the candelabrum first. With your tin snips, cut a 5 1/2″ square of sheet metal. Then cut a curved piece from each side of the square so that it looks like Figure 2.

Next beat the base in order to give it shape and texture, using the round head of your machinist's hammer. Do your hammering on a well-supported surface, such as a sturdy table or workbench, or even on the floor. Place the metal piece on several thicknesses of heavy cloth to cushion the force of the hammer blows.

Then, holding the piece in one hand, beat the metal with the round end of the machinist's hammer. Beat it hard enough to create a series of random indentations over the entire surface. As you strike the metal you will notice that it will start to assume a concave shape as in Figure 3. By controlling the placement of your hammer blows, you can create the concave shape you want. Keep pounding until your base resembles the one illustrated.

It is very important to know that the small indentations will actually strengthen the metal; the more indentations, the stronger the metal becomes. A piece of metal that has been pounded and made concave will

PROCESS

FIGURE 2

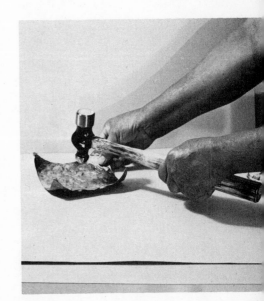

FIGURE 3

97

be able to support weight that previously it might not have been able to support.

Now you are ready to add solder to the base. This will further strengthen it and provide a strong texture which, when finished, will have a patina like that of pewter. Set up the soldering area as suggested previously.

Cover both sides of the piece with soldering paste. Apply the solder to the bottom side first. As you apply the solder, you will notice how quickly and easily it flows as you follow the flame of the propane torch with the extended piece of solder from the roll. Next do the same to the top side. This will give the base the added weight it needs to support the top structure. But just as important, you have the chance to learn the technique of using solder to add texture.

After you have coated both sides of the base, continue to apply solder to achieve the heavily textured surface shown in Figure 4. Timing is very important in creating the lumpy effect. As soon as the solder begins to melt, quickly pull away both the solder and the torch. Removing the heat will prevent the solder from flowing freely so that interesting bumps and lumps will form. Notice that at different times you will get a rich brown-colored effect which will pro-

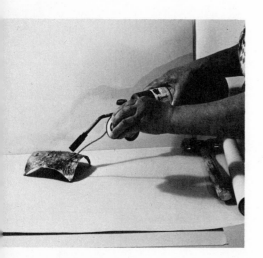

FIGURE 4

98

vide an antique look. This creates a beautiful patina that you can achieve in no other way.

When you have finished texturing the base, stand it upside down and apply extra solder to form a rounded foot on each tip. (This will keep the base from scratching furniture.)

Next cut out the piece that forms the reflector. This piece should be 16″ long. At the base it is 4 1/14″ wide, and it tapers to 3″ at the top. Cut the top like that in Figure 1. This design effect carries the theme of candle flame and also lends a Gothic effect.

Now you are ready to make cuts at the bottom of the reflector in order to form the platform on which the candleholder is placed. First divide the base into five relatively equal parts. Scratch the metal with a sharp object to indicate four cutting lines each two inches long. Then make the four cuts with your tin snips.

Next form the four legs, as shown in Figure 1. Bend the two outer legs forward about 45° and the two inner legs back in the same manner. Then bend the center piece forward at a 90° angle to form the platform for the candleholder.

99

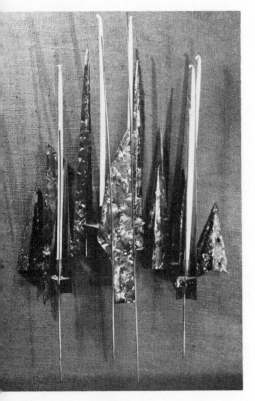

FIGURE 5
John D. Morris. Welded brass.

The reflector will not be pounded as was the base, but will be strengthened by the addition of solder. First cover the back of the piece with a heavy coat of solder. In doing the front, cover only the edges, leaving the middle area clear so that it will reflect light from the burning candle.

When applying the solder, prop the piece so that the area being soldered is as flat as possible. This will keep the solder from running downhill and will make it easier to create the lumpy, textured effect that you want.

After you have finished texturing the reflector, solder the four legs to the base.

Now you are ready to make the cylinder that serves as a candleholder. The diameter of this cylinder should correspond to the size of the candle you intend to use. A piece that is 1 1/2" tall and 2" wide will form a cylinder to hold a slim taper or a slightly larger candle. Use your needle-nosed pliers to form the cylinder. A somewhat irregular cylinder will suit the piece better than one that is perfectly formed. Solder the seam and then add solder to match the texture of the base and the reflector. Then solder the completed cylinder to its platform.

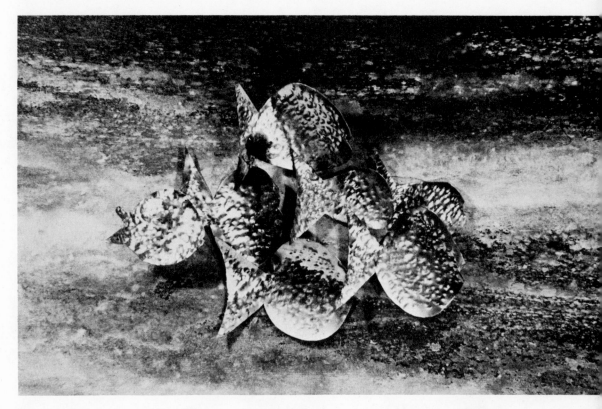

FIGURE 6
John D. Morris. Hammered
sheet metal.

Before inserting the candle, add some
weatherstrip caulking compound to hold
the candle in place. This nonhardening ma-
terial is easy to apply and can be used over
and over again.

After the candle is added, your piece is
ready to be used and admired. An alterna-

101

tive method of creating a candelabrum is shown in Figure 5.

Project 2: Hanging Group of Fish

Another variation using sheet metal and the machinist's hammer is a hanging group of fish. The fish design is a simple one; its interest lies in using one basic shape but varying the size. Also, the shape of the fish can vary. You can use a fat and bulbous fish, as shown in Figure 6, or a sleek and swift-looking fish such as the barracuda (Figure 7). Look at photographs in nature books to stimulate your imagination.

When planning the scale of your piece think of the spot where it might hang.

TOOLS

1. **Soldering equipment,** as described in Chapter 6.
2. **Round-headed** or **machinist's hammer.**
3. **Tin snips.**

MATERIALS

1. **Sheet metal.**
2. Piece of **heavy cloth** to absorb hammer blows.
3. **Paper** and **cardboard** for patterns.
4. Raw umber **oil paint.**

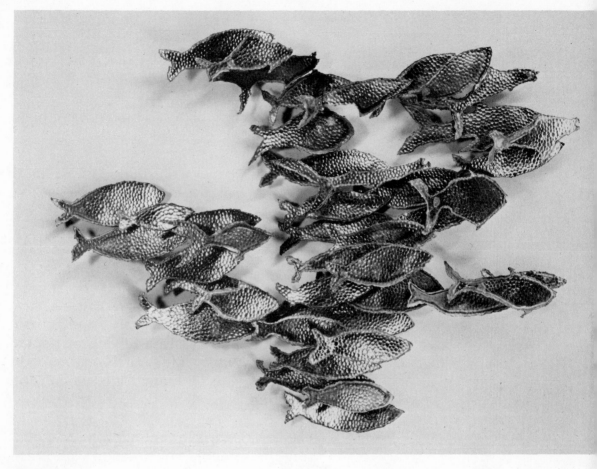

FIGURE 7
William Bowie, *School*. The Sculpture Studio, Inc., New York.

5. Brass **spray paint.**
6. **Fishing line** or **nylon thread** for hanger.

First design your fish on paper and then
make cardboard patterns. Trace around
these patterns on the sheet metal, either by
scratching a line with the head of a nail or

PROCESS

103

drawing a line with a crayon or grease pencil.

Cut out the shapes with your tin snips. Then, using the ball peen hammer, pound the shapes to make them concave. Since you will not be covering the fish with solder, try to cover each fish uniformly with indentations.

Now you are ready to solder the fish together. Place the fish in front of and behind one another to create a feeling of depth. Solder only where they touch one another (here you are using solder for fastening, not for texture).

Next add a patina in the following manner. Spray the soldered construction with brass spray paint. After that dries, rub the entire surface with raw umber oil paint. Then, with a clean cloth pad, buff the surface. This will allow paint to stay in the crevices and the high spots will reveal the bright brass finish, suggesting the scales of a fish.

An interesting place to hang this kind of construction is in front of a window or perhaps a sliding glass door. Suspended from a transparent nylon line or a very thin grey-colored thread, the fish give the appearance of swimming by. Transparent glass

behind them contributes to the illusion that they are floating along. If it happens that you can view the fish from the outside of the window, you will find that the un-painted, convex side is also interesting to view.

Project 3: Wall Plaque Combining Sheet Metal and Copper Foil

TOOLS

1. **Soldering equipment,** as described in Chapter 6.
2. **Round-headed** or **machinist's hammer.**
3. **Tin snips.**

MATERIALS

1. **Sheet metal.**
2. **Copper foil** or **copper flashing.**
3. Piece of **heavy cloth** to absorb hammer blows.

PROCESS

Sheet metal and copper foil can be combined beautifully. The cold bright silver surface of the sheet metal against the warm red color of the copper provides a most pleasing sculptural effect.

In the wall plaque shown in Figure 8, the semirectangular shapes of copper foil were

105

FIGURE 8
John D. Morris. Sheet metal,
copper foil and hot solder.

kept simple to relate harmoniously with the absolutely rectilinear shape of the sheet metal. The copper strips were textured with hot solder to contrast with the smooth surface of the sheet metal. Notice that the solder was applied sparingly so that the red tone of the copper shows through. The irregular central shape is made of sheet metal and coated with hot solder. It creates a focal point, or center of interest, and sets up a relationship with the solder-coated copper and the rectilinear sheet metal.

When the pieces were assembled, the copper strips and the irregular central shape were placed at different levels. This was

106

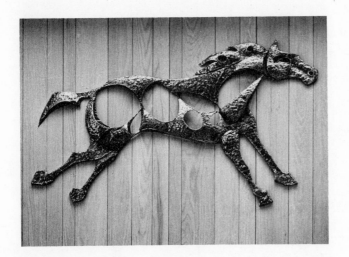

John Lefkow, bronze relief. Mineola High School, Mineola, New York. *Photograph by Carl J. Leonardi.*

done by soldering metal supports to the back of the copper strips and then soldering them to the sheet metal. The different levels of copper strips lend depth to the plaque.

For the base, cut a piece of 1/2" plywood, allowing at least 4" for a border around the plaque. Cover this plywood base with some red burlap attached at the back with either tacks or staples. If you feel adventurous, you may want to select textured cloth of another color, although red is recommended to add just the right touch to the finished metal sculpture. Now you are ready to attach the assembled plaque to the base. You can nail it on with eight very small brads or,

107

if you prefer, you can drill holes in each of the four corners and nail the plaque to the base through these corners.

A base can be made without the cloth covering by simply staining and varnishing the plywood and mounting the plaque directly onto the wood.

Project 4:
Embossed Copper Foil

TOOLS
1. **Tin snips.**
2. **Scissors.**
3. **Embossing tool** (pencil or desk pen).

MATERIALS
1. **Copper foil.**
2. **Tracing paper.**
3. **Liver of sulpher,** if desired.

PROCESS
Copper foil, because of its thinness, has greater flexibility than other heavier forms of metal. This thinness and flexibility allow it to be embossed. The wall plaque with the four horses (Figure 9) is an example of embossed copper foil.

First draw the subject you wish to emboss on tracing paper. Then place the tracing

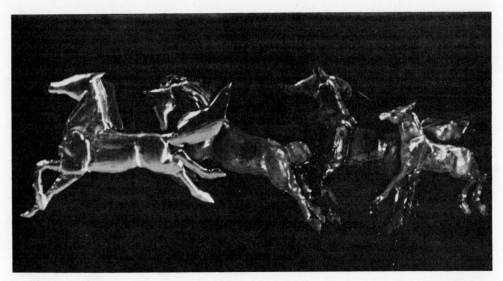

FIGURE 9
Deborah Gurley, Stimson Junior
High School, Huntington, N. Y.

paper over the copper foil, and place the foil on a flat surface with some "give," such as a magazine. Trace over the design with a pencil, pressing hard enough to transfer an outline onto the foil.

Use a slightly dull pencil point or the rounded end of a desk pen to do the embossing. Rub the point back and forth, pressing out the metal to form the contours of your subject. Remember that you are working in reverse, pressing from the back to the front to create the image you want. Emboss the metal most heavily at the points which are to stand out most on the front of the foil.

Notice that some parts of the anatomy of the horse, such as the legs, are pushed further out than the body. This helps to give the illusion of solidity to the form.

109

When you have finished embossing, cut out the form with scissors. You may wish to add a patina. Remember, copper takes liver of sulphur beautifully. Also consider the possibilities of touches of solder to highlight certain design features.

For the base of your plaque, use a board of suitable size which has been stained, perhaps with a rich walnut brown. Then fasten the piece to the board, using epoxy glue or any other available adhesive.

Project 5: Pierced Sheet Metal

TOOLS
1. **Spike.**
2. **Round-headed** or **machinist's hammer.**
3. **Tin snips.**

MATERIALS
1. **Sheet metal** or **copper flashing.**
2. **Insulating board.**

PROCESS
Sheet metal punched full of holes makes a very interesting and eye-catching sculpture. Here is a very simple project, yet its effect commands artistic respect.

110

FIGURE 10
Stimson Junior High School,
Huntington, N. Y.

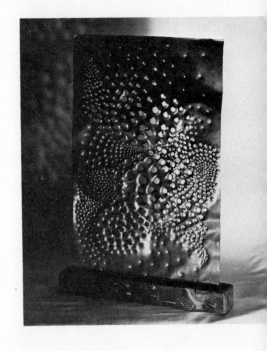

In making the piece shown in Figure 10, the artist first pounded out a few concave shapes on a sheet of copper flashing. Using a spike, he then proceeded to cover the piece with a profusion of holes varying in size. Although the holes are punched at random, a controlled pattern is evident in the design.

A piece of insulating board is good to use as a surface to pound against. It will allow

Germaine Richier, *Sculpture with Background.* Gilded bronze. Collection, The Museum of Modern Art, New York. Blanchette Rockefeller Fund.

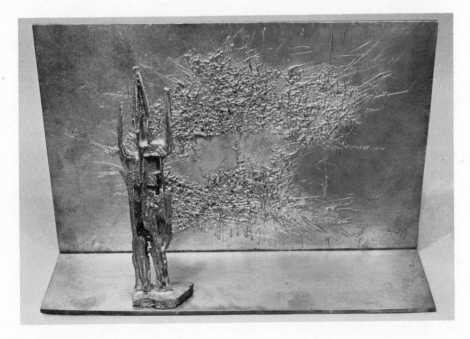

the holes to be easily punched, and the spike can be pulled out of the board without difficulty. If you tap the spike gently, you will get small holes; if you hit it more vigorously, larger holes will result.

William Bowie, *Convolution*. Stainless steel. The Sculpture Studio, Inc., New York.

9

Nails, Nuts, Bolts, and Other Hardware

THE projects described in this chapter make use of mass-produced hardware. A major advantage of this medium is the relatively low cost and easy accessibility of the materials, which are available in lumber and hardware stores.

Nails, nuts, and bolts come in a wide range of sizes, lengths, and weights, and therefore provide infinite design possibilities. You can use a variety of types and sizes, stay with one type but use a variety of sizes, or use just one type and size. However you approach the use of such hardware, your imagination will be stimulated by the challenge of creating something attractive or amusing out of utilitarian objects that in themselves have little intrinsic beauty.

The examples give an indication of the wide range of possibilities in nail, nut, and bolt sculpture. Animals, people, and flowers can

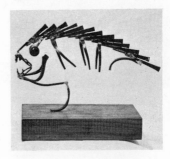

John M. Harra, *Ichthyous.*

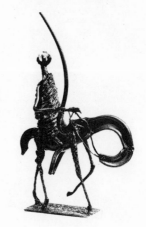

John Russo. Mixed media.

113

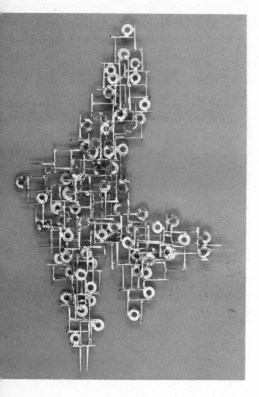

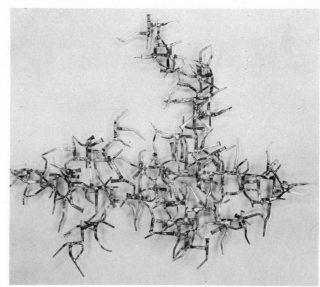

William Bowie, *Sona*. Gold-leafed steel, silver accents. The Sulpture Studio, Inc., New York.

Tac Toe. Polished steel and brass. Silas Seandel Studio, Inc., New York. *Photograph by Gil Amiaga.*

be created, as well as a tremendous variety of abstract forms.

Notice the treatment of the hardware in the works illustrated. In some cases it is evident that the piece is made of nails or of nuts and bolts; parts may be bent, but otherwise they remain in their original form. In other cases the original material has been transcended. Only after study does one recognize the basic materials that were used.

The two major processes you will use in nail and bolt sculpture are bending and fastening. Nails can be bent with a vise and

114

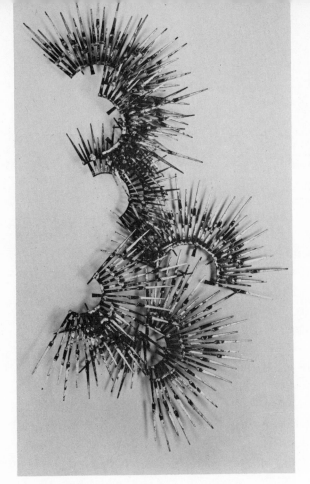

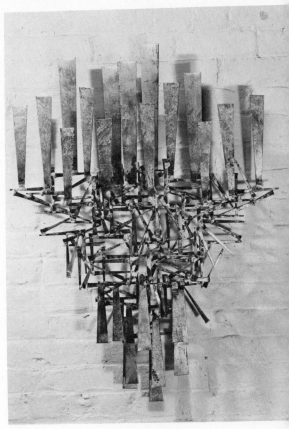

pliers or a mallet. Because of the weight of bolts, you will need to apply heat with your propane torch before bending.

In nail sculpture the fastening can be done with hot solder, as described in Chapter 6. Professional artists who use concrete nails usually weld them together, but you can achieve equally successful pieces by soldering. Just keep in mind that hot solder is soft and not a strong binding agent, so don't expect too much from it. Limit the size and weight of the parts; if they are too heavy they may break at the joint or loosen after a while.

Above left: William Bowie, *Starfire.* Gold and silver-leafed steel. The Sculpture Studio, Inc., New York.

Above right: William Bowie, *Mivaro.* Gold and silver leaf. The Sculpture Studio, Inc., New York.

115

John Russo. Nuts and bolts.

Hot solder cannot be used to fasten nuts and bolts. They are too thick to be heated sufficiently to allow the solder to "take," and too heavy to be held by the soft solder. It is therefore more expedient to use epoxy glue or another cold adhesive which forms a strong bond. Epoxy glue is one of the most durable adhesives. It has one shortcoming, however, that should influence the kinds of projects you undertake: it takes a relatively long time—about two hours—to harden. Keep this in mind when planning your bolt projects and avoid using too many pieces or too many joints.

Nail Sculpture

TOOLS

1. **Soldering equipment** as described in Chapter 6.
2. Assorted **pliers,** as used in previous projects.
3. **Vise.**
4. Leather **mallet** or **hammer.**

MATERIALS

1. **Nails** of various sizes and shapes: forged nails, flat nails, cement nails, brads, etc.
2. **Base,** if desired.

PROCESS

If you plan to use bent nails, bend them first, anchoring each nail in the vise and

116

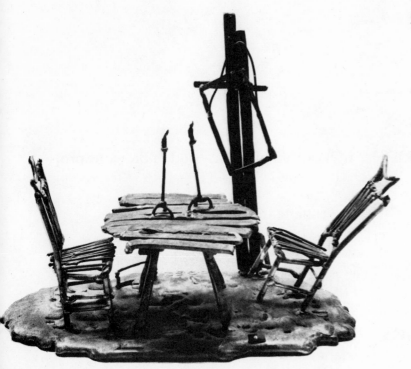

bending it to the desired shape with pliers or mallet.

Next, solder the nails together, using procedures described in Chapter 6. When appropriate, let the solder flow in and around the nails. The solder itself will take on a shape of its own and will give you some very interesting accidental effects.

When you have finished soldering, clean your piece with detergent or soap and mount it on a base, if necessary. If you wish, apply a finish or patina, as described in Chapter 5.

Nut and Bolt Sculpture

TOOLS
1. Assorted **pliers,** as used in previous projects.
2. **Vise.**
3. **Propane torch.**
4. Leather **mallet** or **hammer.**
5. **Clamps.**
6. Disposable **stick** to be used in applying epoxy glue.

MATERIALS
1. **Nuts** and **bolts** of various sizes and shapes.
2. **Base,** if desired.

PROCESS
To bend a bolt, anchor it in the vise and with the propane torch apply heat to the area that you want bent. Bend to the desired shape. Bolts of small diameter can be bent easily with pliers, but much force is needed to bend heavier bolts. If you don't have a leather mallet, wrap your largest hammer with cloth to keep from marring the bolt and to soften the blows.

When you have bent all the members, begin the fastening process. First you will have to mix the epoxy glue, which usually comes in two tubes, an adhesive and a hardener. Do your mixing in a disposable flat container with a hard surface. Mix only the

118

David Smith, *Twenty-Four Greek Y's*. Forged steel. Collection, The Museum of Modern Art, New York. Blanchette Rockefeller Fund.

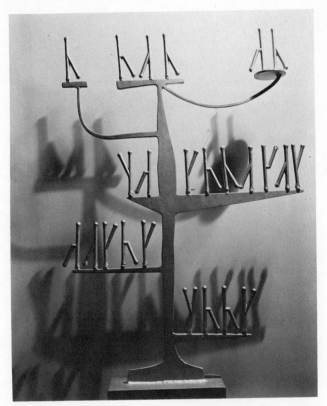

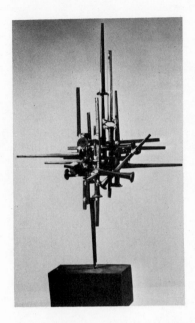

William Bowie, *Cluster*. Steel. The Sculpture Studio, Inc., New York.

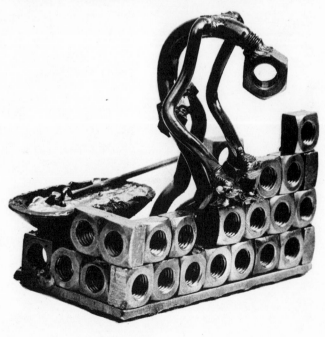

John Russo, *The Mason*.

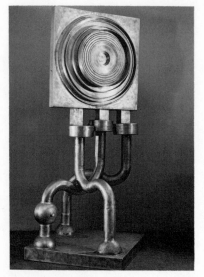

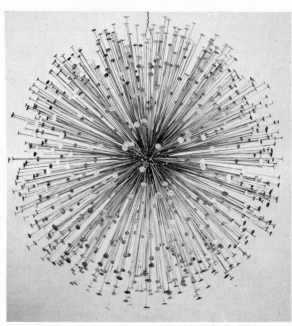

Eduardo Paolozzi, *Lotus.*
Welded aluminum. Collection,
The Museum of Modern Art,
New York. Gift of G. David
Thompson.

amount you plan to use, for leftover glue will harden and cannot be reused. Be sure to read carefully the instructions provided and obey the precautions given; there is no danger if reasonable care is taken. Epoxy glue will irritate the skin, so if you should get some on your hands, wash them with soap and water.

As mentioned earlier, epoxy glue takes up to two hours to dry, so it is advisable to clamp the glued pieces together while they dry. Moderate heat from an infrared lamp or other heat source can be used to speed the drying process.

If the glued joints are too obvious, you may wish to cover the entire piece with a finish or patina, as described in Chapter 5.

120

10 Sculpture with Found Objects– "Junk" Sculpture

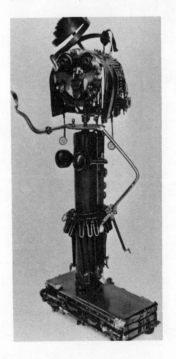

David Strouse, *Mechanical Woman.*

SCULPTURE made from found objects, sometimes called "junk" sculpture, is another important means of self-expression. Fascinating effects can be achieved by discovering things that have long since lost their functional value and assembling them into combinations with unique visual appeal.

The idea of making sculpture from found objects has attracted home hobbyists and serious artists for a number of reasons. One appeal is learning to see beauty in things that have been discarded as worthless. Next there is the challenge of seeing a relationship among a number of discarded objects and putting them together into an assemblage that has aesthetic value. In addition there is the very real joy of "getting some-

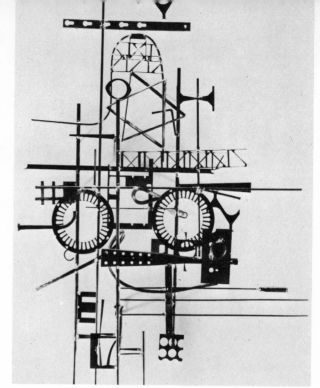

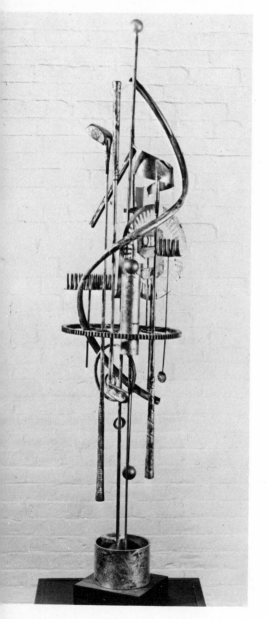

William Bowie, *Double O.* The Sculpture Studio, Inc., New York.

William Bowie, *Golf Sculpture.* Gold-leafed steel. The Sculpture Studio, Inc., New York.

thing for nothing," for found objects are undeniably inexpensive.

The scope of junk sculpture is enormous. At one end of the scale are the small pieces you can hold in your hand. At the other is a work such as the *Towers* of Simon Rodia in Watts, California (Figures 1–5). The scale of this work is monumental: it occupies one-quarter of a block, and the tallest of the towers measures close to one hundred feet. The amount of time and effort that went into this work is even more impressive. Rodia, an immigrant tile setter with little formal education, worked on the towers from 1921 to 1954. The framework was made of steel rods and chicken wire covered with concrete. The decoration consists of broken crockery and pop bottles, seashells, stones, and other found objects.

122

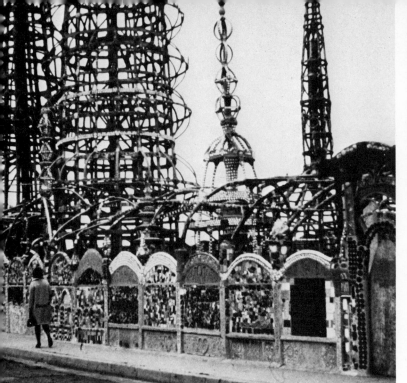

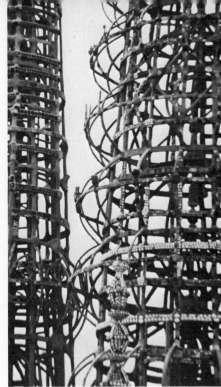

FIGURE 1
Simon Rodia.

FIGURE 2
Simon Rodia.

FIGURE 3
Simon Rodia.

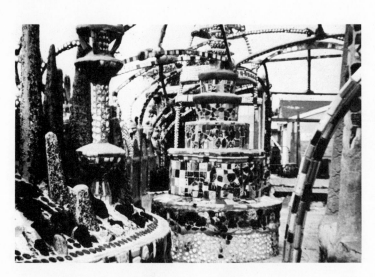

FIGURE 4
Simon Rodia, detail.

FIGURE 5
Simon Rodia, details.

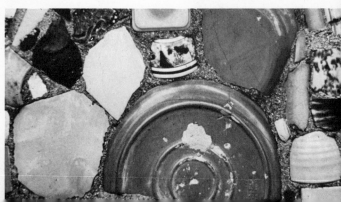

Simon Rodia's work has been called the greatest piece of American folk art, and it is undoubtedly the largest and most elaborate example of sculpture with found objects.

A junk-sculpture purist uses nothing but found objects. He does not go to the hardware store and purchase interesting-looking gadgets and fittings to use in his sculpture; instead, he uses only objects he has collected. In truth, however, some sculpture that is classified as found-object sculpture was done with things that could have been found, but which were, for the sake of expediency, purchased expressly for use in sculpture projects. In one "school" of junk sculpture, the pieces are conceived, constructed, and titled with humor and even

Manuel Rivera, *Metamorphosis (Heraldry)*. Collection, The Museum of Modern Art, New York. Gift of Mr. & Mrs. Richard Rodgers.

124

whimsy. Further along this line is junk sculpture which makes an ironic comment on the by-products of our technological society.

How does one get started in making sculpture with found objects? First one has to find objects that can be combined in interesting ways. This takes time, unless one is very lucky, but more importantly, it takes sensitivity. In short, one must develop new habits of seeing. With the hectic pace of life today, we are usually in too much of a hurry to see what is around us. We need to slow down and look around. There are many fascinating things, if we could only see them.

Also, with our stress on the new and shiny, we tend to ignore and devalue anything that is old or obsolete. There are many things that we consider ugly, such as rusted metal, twisted rods, and odd-shaped things that have been aged by oxidation. And that quality is a special kind of beauty; a beauty that we can enjoy if we abandon long-held opinions that there can only be beauty in the new.

There is no limit to the kinds of objects that can be incorporated into "junk" sculpture. One must develop keen interest in and objectivity toward all sorts of objects that are

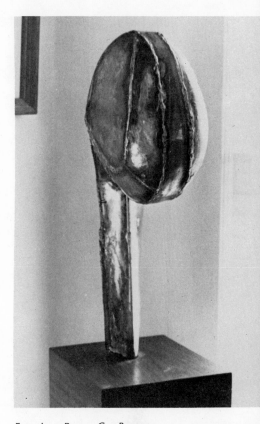

Francisco Perez, *Car Bumper.*

125

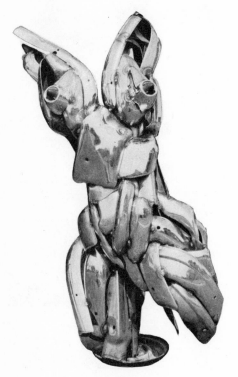

John W. Kearney, *Torso.*
Welded steel bumpers.

on their way to the trash pile or incinerator. For example, the cans in which foods are packaged can be used in myriad ways. A discarded alarm clock is crammed full of fascinating springs.

If your trash at home seems to offer few possibilities, start looking farther afield. Certain industries are sure to have trash of interest to junk sculptors—machine shops and electronics manufacturers, for example, and even your local garbage dumping grounds. Let us assume that you now have a scrap box full of interesting junk. The next step is design: finding a number of objects that have possible relationships in terms of size, color, or texture.

In planning a junk sculpture project, try not to tamper with the quality of your raw material. Take care to retain its original characteristics and especially its surface texture. This surface texture and color cannot be duplicated by any mechanical process; natural changes in metal that has aged slowly has a distinctive quality that cannot be achieved artificially. Also, try not to change the original shape of a piece, for that too is an important element in junk sculpture. A piece that you incorporate need not even be complete. The quality that attracted you to it in the first place should be retained,

126

for that is part of the beauty and intrigue of junk sculpture.

When you have a pretty good idea of how you want the pieces to relate to each other in a whole, you have the problem of fastening them together. Here you will have to call upon all your previous experience and to seek new and different ways of fastening.

Soldering will work only with relatively small pieces of raw material. When in doubt, it does no harm to try. In many cases junk pieces will have a finish that will not "take" the solder or that will be too thick to heat through.

You will be able to fasten some pieces together with wire. Others you may be able to fasten together with nuts and bolts.

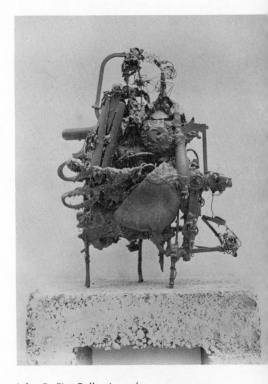

John R. Fix. Collection of Mr. and Mrs. John Meyer, Norwich, Connecticut.

In many cases your best fastening agent will be epoxy glue; it will adhere to just about anything, and also has the advantage of being waterproof, heat resistant, impervious to chemicals, weather, and the effects of time. Although epoxy glue is a very strong adhesive, do not expect it to accomplish the impossible. Try to assemble your parts so that they fit into each other. Use gravity as a holding force whenever possible, and avoid having individual members extend

127

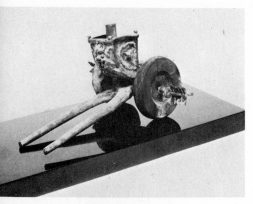

FIGURE 6
Francisco Perez, *Chariot.*
Included are pliers,
grinding wheel, brads,
and the foot of a chair.

Donald Riker, *Brass Slag Horse.*
Made by pouring hot metal
on sand.

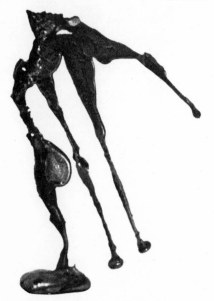

too far from the center of gravity. The weight of each piece will determine how far it may extend and how much adhesive will be required to hold it. The brads on the chariot wheel exemplify this (Figure 6).

If your piece is small, you will be able to use epoxy glue in tube form. Follow the procedure described in Chapter 9.

If you are tackling something relatively large, you will be better off purchasing glue in half pint or pint containers. Mix a small amount at a time to avoid waste. The glue generates heat as it is mixed, and for this reason it is wise to use a shallow container. In a deep container the glue will heat more quickly and thus will solidify faster.

Epoxy glue should be applied with a disposable stick, preferably one with a pointed end. Follow the clamping procedure described in Chapter 9.

In constructing junk sculpture you will have to do a great deal of experimenting, so don't worry about making a mistake. If you fail, you can, in most cases, start again. You will learn a great deal about the properties of various metals through your trial and error procedures, and this knowledge will help you in future projects.

128

11

Mobiles

MOTION has a fascination for every-body. The flickering of a fire, a brook flowing on its course, the flight of birds— all attract and hold the eye. If you imagine for a moment a motionless fire or a still brook, you will appreciate how strongly we are attracted by the dynamic quality of movement.

A mobile is a piece of sculpture that em-bodies movement. More accurately defined, a mobile is "a hanging or standing con-struction or sculpture of delicately balanced movable parts, which describe rhythmic patterns through their motion."

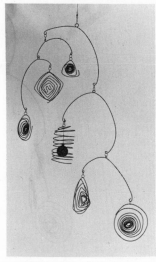

Helen Morris.

George Schormann.

As mentioned earlier, Alexander Calder was the first to develop this kind of moving sculpture. He took lines and shapes and put them together in a fashion that allowed their elements to move about in space and to interact with each other in various ways. In doing so he added the dimension of time or change to otherwise static elements.

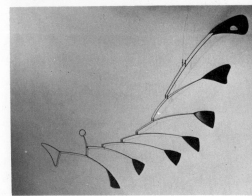

Calder's mobiles, and a great many mobiles which followed, employ organic or natural

129

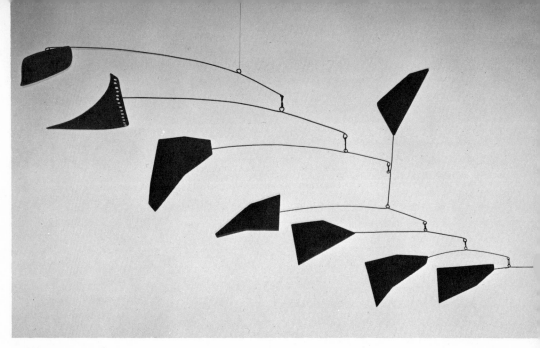

Alexander Calder, *Machine Gun Traces.* Perls Galleries, New York.

shapes. As currents of air act upon these shapes and set them in motion, the movement of the shapes in space reminds us of leaves quivering on branches, globs of light reflected on water, sunlight sprinkling through the leaves of a tree. Like nature, the movement of a mobile is ever-changing and unpredictable.

What enables a mobile to move? To answer that question we must look at the construction of a typical mobile and examine its parts. Though no two mobiles are alike, all have three basic parts: hanger, stems, and shapes. These can be identified in Figure 1.

The *hanger* is a piece of thread or fishing line from which the mobile is suspended. The *stems* are pieces of wire that form the main structure of the mobile. The *shapes* are the decorative elements that hang from the stems; they are usually made of metal, though many different materials can be em-

130

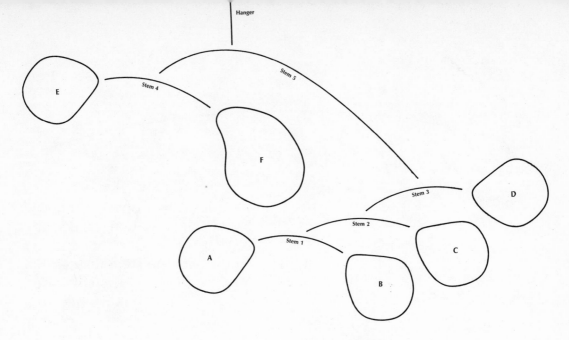

FIGURE 1
Basic parts of a
six-shape mobile.

ployed. The stems and shapes are con-
nected so that they balance. Shapes A and B
are balanced on Stem 1. Stem 1 and Shape
C are balanced on Stem 2. Stem 2 and Shape
D are balanced on Stem 3. Shapes E and F
are balanced on Stem 4. And Stem 5, the
main stem, balances Stem 4 and all the parts
which hang on Stem 3. Stem 5 is likewise
balanced on the hanger. This is not a pre-
cise mathematical balance. You will see
how easy it is to achieve the proper balance
when you begin to make your first mobile.
This physical balance is one feature that
makes it possible for a mobile to move
gracefully.

In addition, the way that the parts are con-
nected has a great deal to do with the way
they move. First let us take a closer look
at the parts of the stem in Figure 2. The
stem typically has a loop at the top with
which it is connected to other stems or to
the hanger. The loop is placed so that the

131

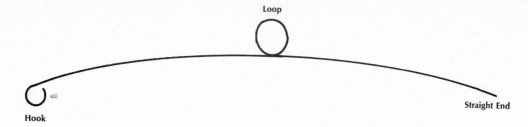

Loop

Hook

Straight End

FIGURE 2

FIGURE 3
Use of rings to connect stems.

parts below it balance properly. You will learn later how to determine the balancing point. Notice that the loop is above rather than below the stem. The stem may end in a hook, created by bending the stem *under*, or it may be left straight and attached to a shape.

One stem is attached to another with *rings*, as shown in Figure 3. A ring, simply a circle of wire, is placed between the hook of one stem and the loop of another. The number of rings affects the position of the stems it connects when they are at rest. Two stems joined by one ring tend to stay on the same plane, as shown in Figure 4. Two stems joined together by two rings tend to hang at right angles to each other, as in Figure 5.

The number of rings also influences the mobility of the parts. One ring will allow the stem below it to rotate 90°, two rings will allow it to rotate 180°, and three rings will allow it to turn 360°.

A fishing swivel can be used to connect the main stem to the hanger, as shown in Figure 6. This allows the entire mobile to rotate freely in any direction.

The mobile is designed to allow every piece to rotate freely in its own orbit. Look at Fig-

132

FIGURE 4

FIGURE 5

FIGURE 6

133

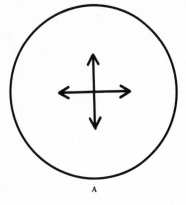

A

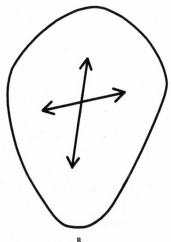

B

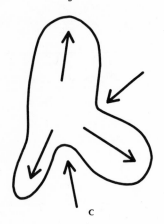

C

ure 1 again. Notice that each part of the mobile can rotate 360° without hitting any other part.

We have seen that the manner in which a mobile is constructed enables it to move gracefuly. Let us now look at the design. A mobile at rest is a series of lines and shapes. The lines are either relatively straight or gently curved. The shapes are rather simple; they often echo each other, but they always relate harmoniously to one another. The lines and shapes are kept simple in order to allow movement to be the dominant quality of a mobile. If complicated angles and intricate shapes were used, the eye would be distracted by the details and unable to appreciate the movement.

Let us look at the shapes themselves. Curved lines and irregular shapes are used more often than precise geometric shapes. Square or rectangular shapes seem to fight the graceful and circular movement of a mobile. A circle is certainly a curved line, and is the most complete shape, but it is not used often in mobiles because of its regularity. A more dynamic quality can be achieved by a degree of distortion. Let us take the arc of a circle and distort it, as in Figure 7. Shape B, a distorted circle, has far more excitement than Shape A. But there is a

134

point beyond which you should not go. If the shape becomes too irregular, as in Shape C, it is too dynamic and it destroys the serene quality one wants to achieve.

In general the shapes used in a mobile should harmonize with its total structure. Rather than fighting against the stem which carries them, the shapes should form a logical continuation.

The spacing of the shapes on the stem is also important. The distance of the shapes from each other and from the various stems have an important bearing on the harmony of the whole. In a mobile you must consider *negative* space, or the air between the shapes, as well as the shapes and the stems themselves, which represent positive space.

Making a Trial Mobile of Cardboard

It is recommended that you make a trial cardboard model of your first mobile, and that you closely duplicate the mobile shown in Figure 8. Follow the directions carefully in order to become familiar with the procedures. In this way you will learn to handle the wire with confidence, and to make long, graceful curves without producing kinks. You will gain practice in making loops and hooks, and you will see how a different

135

FIGURE 8
John D. Morris.
Example of mobile to be built.

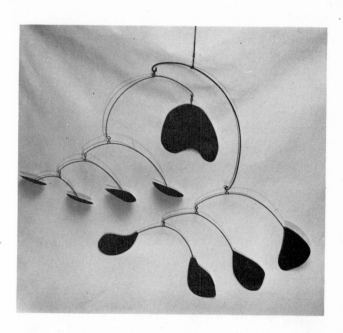

number of rings affects the amount of swing. The shapes you cut out of cardboard can be improved until they suit your taste, and then they can be used as patterns for cutting the metal shapes for your final model. And, of course, you will have a chance to learn how to balance the individual parts and the entire mobile.

When you have completed the cardboard model, you will have acquired the techniques that will enable you to produce a very professional-looking metal mobile.

136

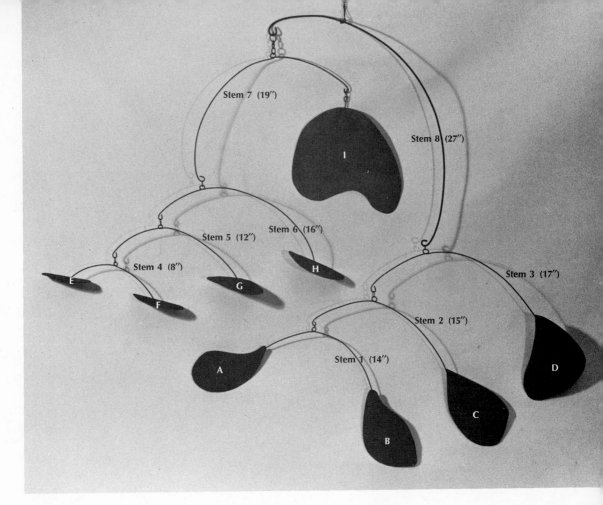

Stem 7 (19″)

Stem 8 (27″)

I

Stem 6 (16″)

Stem 5 (12″)

Stem 4 (8″)

H

Stem 3 (17″)

E

F

G

Stem 2 (15″)

Stem 1 (14″)

D

A

C

B

FIGURE 9

TOOLS

1. **Needle-nosed pliers.**
2. **Side cutters.**
3. **Shears** or **mat knife.**

MATERIALS

1. A large sheet of two-ply **cardboard,** or any cardboard that is thick enough to hold its shape without bending or curling.
2. **Thread** or **string** for use in balancing and for making the hanger.
3. **Swivel** for hanger. Ask at any store that sells fishing equipment for the kind of swivel that holds a plug or leader.

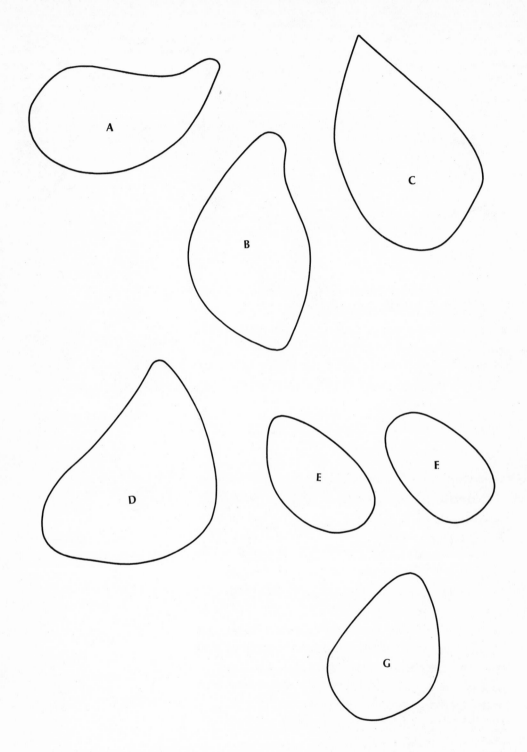

A

B

C

D

E

E

G

138

FIGURE 10
(continued)

4. **Acrylic spray paint** in two colors (black and red are recommended).
5. Galvanized **wire** for stems and rings: 12-gauge wire for main stem, 16-gauge wire for balance of stems, and 20-gauge wire for rings. Refer to Figure 9 for help in estimating quantities needed.
6. **Masking tape.**

PROCESS

The first step is to cut out Shapes A–I in cardboard. Duplicate the patterns, pages 138 and 139 (Figure 10), but make them larger than shown. Draw them on your cardboard and cut them out. If your cardboard is too thick to cut with shears, use a mat knife. Label each shape by letter as you cut it, for easy reference later.

Now you are ready to begin constructing the mobile. It is most important to begin at the bottom and to build to the top. This enables you to balance each section as you go. The most common mistake that begin-

ners make is trying to work from the top down.

Using 16-gauge wire, cut Stem 1 to a length of 14 inches. (Note that the length of each stem and the shapes it supports are indicated in Figure 9.) It is important to learn how to handle the wire without kinking it, for once a kink is formed, it is there for good. As you take the wire from the roll, run the cut length through one hand, pulling it with the other (Figure 11). As you cut the wire, do not interfere with its natural curl (Figure 12). With practice you will learn to cut stems with the slow graceful curve that is essential to a successful mobile.

FIGURE 11

Now you are ready to attach Shapes A and B to Stem 1. Place the two shapes on a flat surface, positioning them as shown in Figure 13. Position Stem 1 over the two shapes, allowing 2″ of wire to overlap each shape. Fasten the stem to the shapes with masking tape.

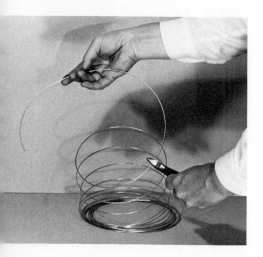

FIGURE 12

Next determine the balancing point for Stem 1 by looping a piece of thread around the stem near its center, and letting the section hang, as in Figure 14. Experiment by moving the thread closer to or further from Shape A. Notice that the closer the balancing point is to the shape, the higher the

140

Shape A Shape B

FIGURE 13

FIGURE 14

Shape A Shape B

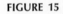

shape will be. Locate your balancing point for Stem 1 at the asymmetrical position shown in Figure 15. Shape A will hang slightly higher than Shape B; this was done to provide a more interesting relationship. Also, the two shapes will balance more satisfactorily when the rest of the structure is added.

FIGURE 15

When you have the two shapes balanced satisfactorily, you are ready to make the loop with which Stem 1 will be attached to Stem 2. To do this, grasp the stem with the needle-nosed pliers at the balancing point (Figure 16). Hold the section perpendicular to you. Grasp the end of the wire away from you and bend it over the nose of the pliers toward you. Continue until the wire is about three quarters over the pliers (Figure 17). Change the position of the pliers to the top of the wire (Figure 18), then continue bend-

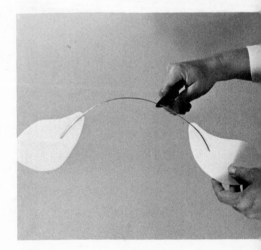

FIGURE 16

141

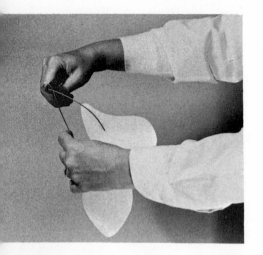

FIGURE 17

FIGURE 18

ing the wire until the loop is complete (Figure 19). Now place the pliers on the bottom where the two wires cross and pinch them together (Figure 20). Holding the pliers at that point, shape a graceful curve.

Now cut Stem 2 to a length of 15 inches. Make a hook at one end of the wire with the needle-nosed pliers (Figure 21). Do not close this hook because you will slide a ring onto it later. Remember the end hook is bent *under*. Fasten two inches of the other end of the stem to Shape C with masking tape.

Now you will need a ring with which to attach Stem 1 to Stem 2. You will need a total of ten rings, which can be made all at once. Take a piece of 20-gauge wire and wrap it around a round pencil ten times. Remove the wire from the pencil and use your side cutters to cut the wire into ten pieces. Then flatten them into rings.

Slip one ring into the loop of Stem 1 and pinch the cut ends together with pliers. Holding Stem 1 with Shape A on the left, slip the hook of Stem 2 into the ring, as shown in Figure 22.

Wrap a piece of thread around Stem 2 to determine the balancing point. Your prob-

lem at this point is to get the right spatial relationship between Shapes C and B. As you can see in Figure 22, if the thread is too close to Shape C, the distance between B and C is too great. If the thread is too close to the loop, as in Figure 23, B and C are too close. You must determine the position that is just right, as in Figure 24, for this relationship will affect the placement of all subsequent shapes. If the shape is too high, it looks isolated; if too close, it looks cramped. When you have found the right balance, you are ready to make the upper loop in Stem 2. (Before bending Stem 2 to make the loop, remove Stem 1 for easier handling.) This loop is where Stem 3 will attach to Stem 2.

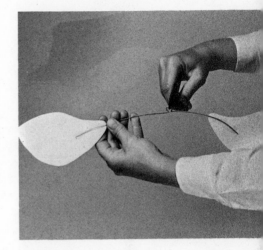

FIGURE 19

Now cut Stem 3 to 17 inches and follow the same procedure to attach Shape D and to make the hook at the other end. One ring is used for this connection because we want Shape D to be on the same plane with Shapes A, B, and C. Again remove Stems 1 and 2 before making the loop in Stem 3. Now close all the hooks and make sure the rings are secure. You have now completed the right side of the mobile and are ready to start on the left side.

Cut Stem 4 to a length of 8 inches with your pliers, and bend the two ends of the stem,

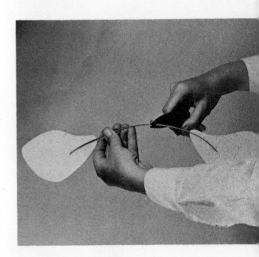

FIGURE 20

143

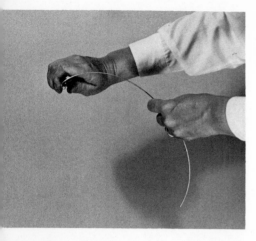

FIGURE 21

as shown in the Figure 25. Place one end of the stem on Shape E and the other end on Shape F, as shown. Attach both shapes to the stem with masking tape. Next determine the balancing point and form the loop. Add a ring. Proceed in the same manner with Stem 5 (12 inches) and Shape G; and Stem 6 (16 inches) and Shape H. Be sure to add a ring to each loop before attaching it to the next stem.

Cut Stem 7 to 19 inches and form a hook on each end. Shape I is attached in a slightly different manner with a ring that has a short stem that is taped to the shape (Figure 26). Add one more ring to Shape I. Insert one hook of Stem 7 into the ring of Shape I, and the other hook into the loop of Stem 6. Now balance Shape 1 and Stems 4, 5, and 6 and their respective shapes. Form a loop in Stem 7 at the balancing point. Close all the hooks and rings in the left side of the mobile.

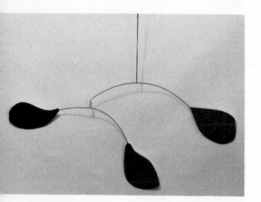

FIGURE 22

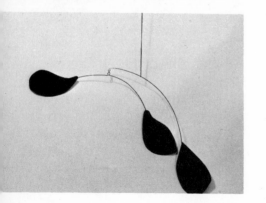

FIGURE 23

Now you are ready to cut the main stem, Stem 8, which balances the two sides of the mobile. Use 27" of 12-gauge wire for Stem 8. Form a hook at each end. Add three rings to the loop of Stem 7 and one ring to the loop of Stem 3. Attach one end of the main stem to the top ring of Stem 7 and the other end to the ring of Stem 3. Now determine

144

the balancing point of the main stem. This is the most critical balancing of all, because it determines the relationship of the two halves of the mobile. When you have found the balancing point, make the loop in the main stem and connect it to the swivel so that the entire piece can swing freely. Close the hooks in the main stem.

The last step before hanging the mobile is to add color. Let us consider the reasons behind making a choice of colors. Not only are you concerned with the balance of shapes, but with the balance of color also. But here, too, simplicity is important. The use of many different colors can create a "busy" feeling that detracts from the over-all effect.

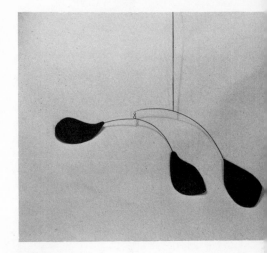

FIGURE 24

In the model for the mobile you are making, all stems, rings, and shapes are painted black, except Shape I, which is painted red. Applying a bright color to Shape I, the largest shape, provides a color balance and creates a focal point which balances the two halves of the mobile. You can experiment with other colors on your cardboard model before making a final decision for the metal one.

Hang your cardboard model so that you can study it. A mobile shows off well when

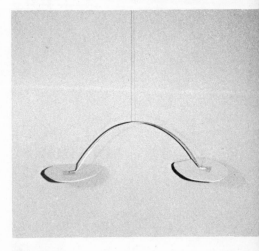

FIGURE 25

145

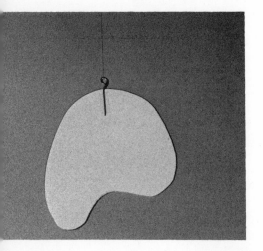

it is silhouetted against a blank wall or ceiling so that it contrasts with its background. Watch your mobile move, and notice the interplay of the stems and shapes. If you see things you would like to improve, experiment with your cardboard model before going on to make the final metal mobile.

You may want to change the shape of the shapes, alter the position of the shapes on the stems, or move the loops to modify the balance.

FIGURE 26

Making the Metal Mobile

ADDITIONAL TOOLS

1. Metal **shears,** not larger than 7″ (if too large, they will make cutting difficult). The kind with curved blades will prove easier to handle.
2. Soldering equipment, as described in Chapter 6.

ADDITIONAL MATERIALS

You can use the **thread, swivel,** and **paint** used in making the cardboard model. Check your supply of 12-, 16-, and 20-gauge **wire** to make sure you have enough. In addition you will need:

146

1. A piece of **sheet metal** large enough for all the shapes.
2. Fishing line for the hanger.

PROCESS

You will follow the procedures used in making the cardboard model, except that instead of attaching the shapes to the stems with masking tape, you will use hot solder. Solder each piece as you go. Again, start from the bottom and work up.

In locating the balancing point for each stem, you can be guided to some extent by the cardboard model. It is wise, however, to check each balancing point, using the thread technique, before making the loop.

In making this mobile you have acquired the necessary techniques and knowledge to be able to solve most problems with future mobiles. As you can see from the example photographs, there are many variations possible. With the number of materials available and the infinite variety of combinations and balances that can be used, there should be countless ideas for mobiles running through your head. You can make them out of plastic, glass, metal,

147

Right: Alexander Calder, *Moma (Whale).* Perls Galleries, New York.

Below right: Alexander Calder, *Hang It All.* Perls Galleries, New York.

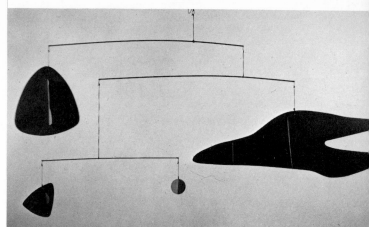

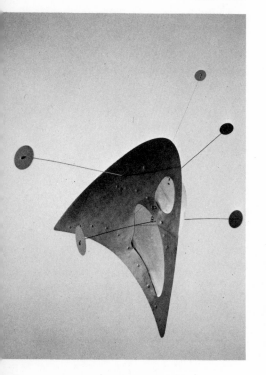

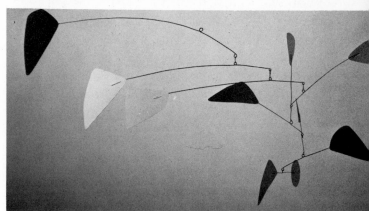

Alexander Calder, *Horse's Skull.* Perls Galleries, New York.

foil, cloth, and just about any other material. The shapes can be textured, pierced, or attached to one another in different ways. Look around, especially in museums and art galleries, to see how the professionals do it. Don't be afraid to borrow ideas.

There are many places to hang mobiles around the house and office. And, of course, a metal mobile can also be hung outdoors. Give your imagination free rein and enjoy the excitement of creating mobiles.

148

12 Extensions

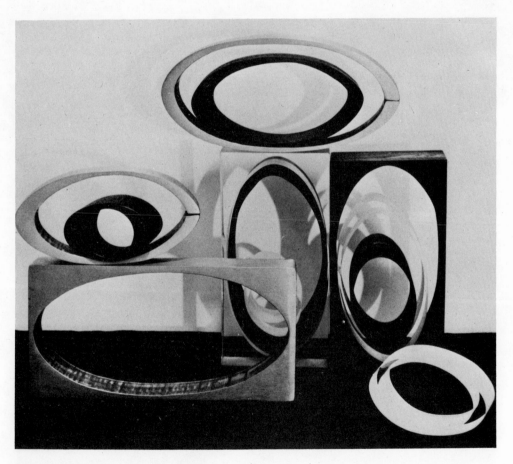

Doris Chase. Steel, wood, and plexiglass.

Francisco Perez. *Seated Pan.*

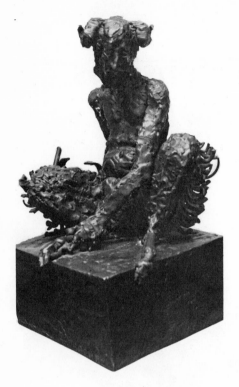

Judith Brown.

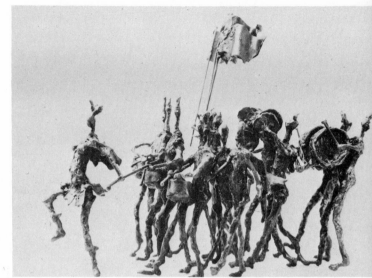

Pablo Picasso, *She-Goat.*
Bronze. Collection, The Museum
of Modern Art, New York.
Mrs. Simon Guggenheim Fund.

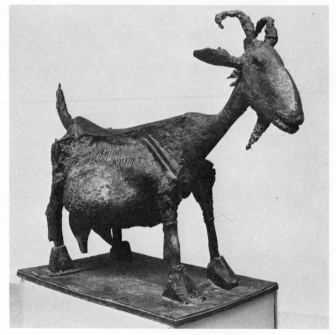

150

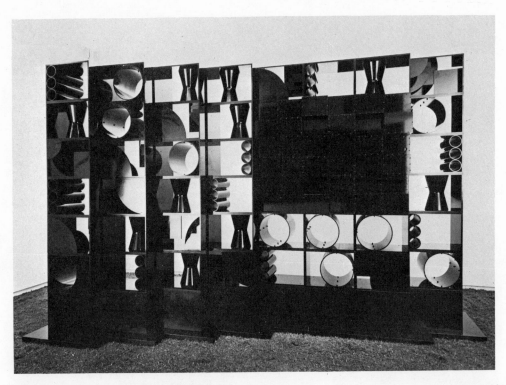

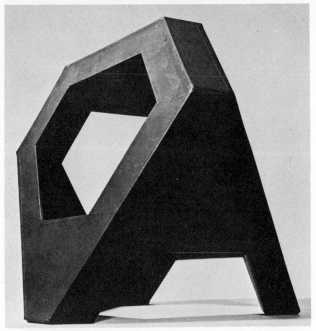

Above: Louise Nevelson, *Atmosphere and Environment*. Baked enamel on aluminum. Photograph by Ferdinand Boesch.

Left: Tony Smith, *Generation*.

Index